110218

The Artificial of the Real

This exhibition was made possible by the generous support of the DG BANK.

Anton Josef **Trčka**

with texts by **Carsten Ahrens, Monika Faber, Rudolf Kicken,** and **Michael Stoeber**

Edward **Weston**

edited by **Carl Haenlein**

Helmut **Newton**

Kestner Gesellschaft

Scalo Zurich – Berlin – New York

About this exhibition

Early on, indeed from its very inception, photography was recognised as an out-standing medium for the artistic imagination. The exploration into the realms of human portrait and landscape pursued by eminent nineteenth century photographers created instruments of cultural perception of the highest precision. The dialogue between the new medium and the classical arts was initially carried out on a subcutaneous level. But with the contributions of Stieglitz, Steichen and Man Ray, this interaction fostered an unforeseeable degree of proliferation in the fields of pictorial creativity.

Galleries and museums naturally responded to this phenomenon, and since the twenties the examination of photography has become a tradition in the Kestner Gesellschaft. Evidence of this is offered by such wide-ranging thematic exhibitions as *The Beauty of Technology* (1926), *Contemporary Photography* (1929), *Artistic Photography in the Twentieth Century* (1977), *Dada Photomontage* (1979), *American Photography 1920–1940* (1980), *Artistic Photography Fleeting Image* (1982) and *Photography and Bauhaus* (1986). Continuing the series of monographic exhibitions featuring *Raoul Hausmann* (1981), *Hans Bellmer* (1984), *Benjamin Katz* (1985) and *Astrid Klein* (1989), the latest show *Trčka Weston, Newton—The Artificial of the Real* loosely groups three major photographers, assembling three monographic exhibitions as it were, under one roof.

The preoccupation with the body, its instrumentalisation and sublimation has evolved into one of photography's major themes. If anywhere, this is where the exhibition's context is to be located. Yet its thematic intention was deliberately kept open—the central focus being reserved for the works themselves, the art, the photography.

The Kestner Gesellschaft expresses its gratitude to Rudolf Kicken for the work he has invested in this exhibition as guest curator. Through his mediation precious loans could be brought to Hanover and his advice proved valuable and utterly sound throughout.

We would particularly like to thank Margaret and Matthew Weston from Carmel, California, who for the first time on this scale allowed their Edward Weston treasures to be appreciated in public for a limited period. The same goes for Hanna and Manfred Heiting who also placed part of their splendid collection of Weston photographs at our disposal for the Hanover exhibition.

In addition, we would like to express our warmest appreciation for the kind support given by Gert Elfering and Susanne Ulrich at Camera Work in Berlin, and by Martina and Ulrich Finkam, Steven Josefsburg, Lela and Sascha Kubesch, Alexander Hornemann and Sebastian Turner.

We are indebted to the family of Anton Josef Trčka, who for this show readily placed a large amount of photographs at our disposal for the first time, and especially to Dr Monika Faber in Vienna who discovered the excellent œuvre of this much underestimated photographer. Without her tireless effort Trčka's pictures could not have been shown.

Our thanks also go to June and Helmut Newton who contributed greatly to the selection and dramaturgy of the pictures—not forgetting Veronique Noé at Helmut Newton's office, who always had a swift solution for any problem, and Dr Brigitte Schlüter at the Galerie Rudolf Kicken, who lent us her energetic support in the final, hectic weeks.

Without the generous support of the DG BANK this exhibition could not have been realised in its present form. We wish to thank the DG BANK, and especially Dr Detlef Marquardt, for their commitment in the sphere of photography. Last but not least, the Kestner Gesellschaft wishes to thank the *Land* of Lower Saxony for supporting this project.

Carl Haenlein

Contents

"The ultimate purpose of science is truth — the ultimate purpose of art is pleasure." Gotthold Ephraim Lessing, Laokoon

The Artificial of the Real — Photographic bodies

by Rudolf Kicken

The exhibition *The Artificial of the Real* offers a series of extremely thrilling insights into the creative work of three important — but absolutely different — twentieth century photographers whose work and influence took place in wholly distinct periods and in geographically separated cultural circles but whose work reveals the pivotal role played by the treatment and staging of the body in the photography of our century. The exhibition displays *Photographic Bodies* by Anton Josef Trčka, that talent of Czech origin, unrecognised and bereft of fame during his lifetime, a contemporary of Rudolf Koppitz in Vienna, by Edward Weston, the famous photographer from Carmel, California, and by the cosmopolitan fashion and portrait photographer Helmut Newton who is certainly one of the most famous contemporary photographers of nudes.

The actual focal point of the exhibition is the "body" or rather the "corpus." Corporeality as a theme emerged as an interesting viewpoint for an exhibition during a conversation with Carl Haenlein and Carsten Ahrens from the Kestner Gesellschaft. "Corporeality" should not be understood in terms too narrow or as referring solely to the human body. This exhibition sought to dedicate itself to the portrayal and possibility of portrayal by means of photography of bodies and of corporeality — objective, natural, geographical, geometrical, abstract body-forms. This is the basis of the

joint "performance" of these three photographers who at a first glance do not appear to belong together. However, there is more than one might imagine which connects them. All three are part of an avant-garde — each in his own time, bound up with the spirit of his age. They cross boundaries, wander upon a knife's edge among the photo-artists of their time.

Let us begin with Anton Josef Trčka — ANTIOS. He succeeded in creating portraits of his artist friends such as Egon Schiele and Gustav Klimt with a stark and unique, almost theatrical expressivity. He deliberately employed body language when portraying characters. Of special significance were symbolic gestures of the hands, which — as Monika Faber describes in her essay about Trčka — can be decoded according to the rules of eurhythmy created by Rudolf Steiner whose anthroposophy had an influence upon the contemporary artistic circles of Prague and Vienna which has so far been largely ignored.

Using the hands to heighten body language was quite new and unusual, but it was a logical consequence from the perspective of expressive representation of corporeality and of body language (the portraits of dancers and his nudes are called to mind). Similar themes and representational modes are found in the work of the German photographer Hugo Erfurth, among others.

Then the California photographer Edward Weston, who was always way ahead of his time in his work and belongs to the most influential photographers world-wide. He was capable early on of abstractly "representing" bodily forms — be they human figures, landscapes or plants — in an abstract way. At this point I would like to call attention solely to his famous nude of a man viewed from the back (1925) for which he drew inspiration from Brancusi's sculptures and where he combined his photographic representational means with an artistic-abstract perspective thereby combining "artificiality with reality."

Finally the contemporary photographer Helmut Newton — he violates all borders and conventions without loosing sight of aesthetic considerations or on the other hand emphasising them too much. Newton has created sensitive, precise and strongly characteristic portraits of numerous personalities — whether they be artists, actors or politicians — as well as self-portraits which take a close and critical look at his own, non-timeless corporeality.

He revolutionised fashion photography through his deliberate use of feminine corporeality. His famous diptych *They are coming I/II* (1981) shocked the world. Today the use of the naked female body in advertising and in fashion photography is

no longer extraordinary because the limits of vision have been moved, also because of his work. That he knows how to handle corporeality in a special way is apparent here in the exhibition through the direct comparison in his most recent diptych *Kristen McMenamy* in black-and-white and in colour. It is characteristic of an artist that he is (almost) never satisfied with his own limitations.

As diverse as the viewpoints of the three photographers may be, they offer in any case an exciting insight into the possible ways of portraying and representing corporeality, reality and artificiality.

The fact that the exhibition could be realised in this way is due to the creative and open approach of Carl Haenlein and Carsten Ahrens from the Kestner Gesellschaft with whom it has been once more a pleasure to collaborate. May our pleasure in the work of these three photographers and in the preparation of this exhibition now become the pleasure of all those who allow themselves to be fascinated by *The Artificial of the Real*.

Translation George Frederick Takis

"There is no art, there are only artists"—Marcel Duchamp

The Art of Perceiving the Real—Photography as a gesture

by Carsten Ahrens

Anton Josef Trčka, Edward Weston, Helmut Newton—three photographers with three distinctive approaches to perceiving reality. All three have been drawn together in an exhibition which investigates the notion of physicality without diminishing each artist's unique standpoint. In this presentation of three so different artistic temperaments, the emphasis lies not on the assertion of some polished curatorial thesis, but purely on the artistic vision of photography, a vision in which various attitudes towards reality and our own role within this reality acquire coded, mysterious and creative expression.

For an exhibition so explicitly concerned with corporeality, it nonetheless includes certain aspects which might at first sight appear somewhat puzzling. This is particularly the case with the work of Edward Weston. Whereas Newton's work seems to be overtly preoccupied with the nature of physicality, such allusions in Weston's photography are of a much more discreet, though no less vehement nature. Weston draws our gaze towards a cosmos of visual phenomena in the world. In his photographs, especially those shot in the twenties and thirties, a highly-focused close-up of reality is transmitted as a fragmented metaphor. The object of Weston's photography is the *pars pro toto*, as it were. In the details he has isolated from the chaos of nature, reality is manifested in an elementary and abstract form. Thus, in a

mysterious manner all phenomena are interconnected following the pattern of their structure which his photography suggestively renders visible. Life's comprehensive balance of forces is given visual presence, and everything appears permeated with the vital force of physicality. For this reason, the works selected for this exhibition represent a cross-section of the numerous leitmotifs running through Weston's œuvre, all linked, as if with some imaginary thread, by his distinctive way of viewing the surfaces of physical bodies.

The physical presence of his photographs of shells, the female body and organic forms may seem stylised, yet they are nothing other than the camera's precise observation of real phenomena. Transfigured by the photographic eye, reality metamorphoses into an artificial image of the real — thereby revealing its hidden essence.

Certain aspects of Weston's early work, which bore the hallmark of American pictorialism, do indeed show parallels with the work of Anton Josef Trčka, who in his photographs modelled a portrait of the human being of his time. Both photographer and painter, he himself designed the backdrops and arranged the scenery within which the protagonists of his tableaux acted out their roles. Ornamental compositions, but above all the poses assumed by his subjects (and especially their hands), place great emphasis on the expressive potential of gesture. Permeating these works, which in some secret way appear to poeticise reality, is a strange atmosphere which seems to switch between resignation and departure.

The cultivatedly stylised poses in which Trčka models his figures suggest stagnation and movement embraced in paradoxical juxtaposition. It is as if these pictures were dreaming of the liberation of the bodies which are made the eloquent medium of perception—the longing for release from the rigid corset of bourgeois constraints. In Anton Josef Trčka's photographs, and particularly in his portraits of artists, one still detects a trace of that sensation which can be unleashed by an encounter with another human being.

Helmut Newton has repeatedly and persistently used his photographs to break through fixed boundaries, especially in his contradiction of prevalent views on how the naked, and in most cases female, body should be depicted and published. Helmut Newton began his career as a fashion photographer and is still active in this field today. The provocative arrangements in his pictures have always run counter to what was at the time widely regarded as up-to-date and publishable, further accelerating the symptomatically high turnover rate of innovations within the fashion business. However, far more significant than the constant redefinitions of what

fashion photography can be, is his delicately formulated critique of prevailing systems. Newton operates in one of the most prosperous niches of the global market, where both the human body and the concept of beauty have become retailable commodities, merchandise with a best-before date at that. His photographs take advantage of this exploitation machine, while simultaneously undermining it and shaping a different horizon, against which his work is cast in another light.

The female image created by Weston's photographs is by no means characterised by availability, either as a commodity or in sexual terms. Instead, women assume a physical posture of strength and of tested self-assurance. Yet the nude body in Newton's photographs has in an intriguing way been stripped of everything we normally associate with nakedness. Indeed, the naked protagonists of the often bizarre scenarios enacted in these pictures exude an air of disconcerting normality.

Besides the large-format *Domestic Nudes*, the *Big Nudes* and the *Playmates*, the exhibition also includes Helmut Newton's self-portraits, showing the other aspect, so to speak, of his work. It is here, in these pictures of his own body made during various clinic visits, that Newton exposes with astonishing candidness the fragility of the human body and the pain of isolation.

Photography is the one medium which generally tends to be attributed with the greatest proximity to reality, and yet it is also a medium of projection. The three artistic visions presented in this exhibition each propose models of our perception of reality on various levels of abstraction. There is the poeticising transformation of the real in Trčka's pictures signalling the *élan vital* of the incipient century.

Then the precision of Weston's photographic scrutiny which unveils a world of structural correlation, ushering in a cosmos of elementary forms which for the moment of a glance manifest the essence of life.

And finally there is the theatrical game with the parameters of a commercially structured world as displayed in Newton's pictures, projections which transform the female body into a utopian figure and an artistically stylised counterfoil. The *artificial of the real* so clearly evinced in the positions of each of these three artists, offers an intimation of how our perception can be brought into sharper focus within the parameters of art.

Translation Matthew Partridge

Anton Josef Trčka

Human Figures in Flowing Rhythm

The photographs of ANTIOS (1893 – 1940)

by Monika Faber

A torn man throughout his life, constantly in transit between two worlds — in both a geographical and an artistic sense — Antonín Josef "ANTIOS" Trčka failed to achieve broad recognition either during his own lifetime or after his death. One exhibition in Prague and one in Vienna, both in 1923/24 and symptomatic of his affinity for both Czech and Austrian art: this was more or less all he had to show for himself as a painter. As a photographer he was regarded highly by a few artist friends, painters, poets, musicians and several dancers. Yet his pictures were very rarely published or exhibited. And as a poet, which is how he saw himself in the last two decades of his life, he never managed to see even a single line of his work in print.

Just a handful of loyal followers and enthusiastic admirers grouped around him regularly attended his readings, and after his death they set up a "commemorative room" in his studio/apartment where all his works were to be kept and exhibited — such was the will of his devotees that even Trčka's young daughter and only heir was not allowed to remove and keep a single thing. And as is so often the case, such laudable intentions were ultimately to result in catastrophe, for in 1944 virtually all the works of ANTIOS were destroyed by a single bomb which fell on the house.

All that survived were a few, incidental vestiges which had found their way to friends and family while he was still alive; only in recent years have these gradually

come to light (or been seen for the first time in public). However, four or five photographs exist which have been published again and again, both in the inter-war period and later in the sixties in a veritable flood of catalogues, brochures and books about the Viennese *fin de siècle*, a theme which became increasingly fashionable in the world of art. These works are zealously guarded in the picture archive of the *Nationalbibliothek* and the *Graphische Sammlung Albertina*, two august temples of Austrian high art. These images once used to be catalogued here as self-portraits by Egon Schiele, and only gradually did the name ANTIOS (clearly legible on each photograph) make its way into the indexed directory, a register which names the authors of the institution's accumulated treasures, which did not, however, lead to further inquiries into the actual person behind this pseudonym. Art historians apparently considered the mannerisms of self-display in these photographs to be too close to the famous artist's own drawings and paintings to even wonder if they might not instead represent the interaction of two different personalities.

Yet such proximity might offer a key to this work which is still barely known, let alone properly investigated. For it is surely no accident that these portrayals of Egon Schiele are the only photographic representations of the expressive theatrical poses which the artist otherwise only manifested in his own graphic work, a palette of gestures oscillating between introversion and exaltation, and the curvacious linearity executed with the same severe style of drawing which so unequivocally characterises his portraits. At the watershed between art nouveau and expressionism, Schiele's work meets that of ANTIOS. Whereas virtually all other photographs of Schiele show him in a different light, looking somewhat shy and reserved, in Trčka's work we encounter more, unknown subjects assuming similar poses for his camera — not least the photographer himself in the various self-portraits he took over the years.

Compared with the rest of his œuvre, the expressive and strongly symbolic gestures of the hands prove to be decipherable in relation to the eurhythmic rules established by Rudolf Steiner, whose influence upon artistic circles in Prague and Vienna remains underestimated to this day. As a substitute for religion for progressive-minded or otherwise non-conformist people in the period just prior to and after the collapse of the monarchy, the role played by the anthroposophic movement has only now started to receive attention in our anti-mysticist perception of (art) history. The 1995 exhibition *Occultism and the Avant-garde* in Frankfurt probably marked the inception of a far from complete evaluation of material documenting the little (if at

all) appreciated "byways" within the art of the first half of this century. Such hidden paths beyond the usual "isms," even beyond the commonplace notion of the avant-garde, have for the most part slipped through the grid of perception fostered by the dominant creed of historical progress.

Not only was Trčka (who received no mention in the Frankfurt catalogue) personally acquainted with Steiner — he probably did his portrait in 1918 —, he was also an active participant in the Anthroposophical Society in Vienna over many years, offering his studio as a forum for its readings and dance performances. In Vienna, enthusiasm for the "New Dance" was particularly pronounced, a craze which crowned Isadora Duncan in triumph and later brought forth the idiosyncratic style of the Wiesenthal sisters, Gertrud Bodenwieser and Hilde Holger (who all also mod-elled for Trčka), even attracting the likes of Rudolf von Laban. Such a wave of excite-ment would have been almost unthinkable were it not for the prevailing mood of body consciousness, the belief both in a merely dormant "naturalness" and the transcendence of the physical means of human self-expression. This fervour also enthralled young artists such as Schiele, Kokoschka and ANTIOS. Innovative, un-restrictive clothes like those designed in the *Wiener Werkstätten*, the progressive teaching methods of Eugenie von Schwarzwald, a counter-traditionalist approach to construction such as that of Adolf Loos — all of these phenomena were symptomatic of a new departure which (significantly advanced by Sigmund Freud's radical theo-ries) encouraged a climate of implicit resistance and rebellion.

Inside this multi-ethnic state people were straining at the chains of conven-tion, and Vienna became the meeting-place for all the emerging forces of spiritual activity in search of something new. This city was but one contributive factor to the imaginative universe of the young artist ANTIOS; as a "real" Viennese of this peri-od — as the saying goes even today — his roots were of course no more in Vienna than those of Loos, Freud or Theodor Herzl. To a far greater extent than his friend Schiele (whose mother also came from Bohemia) or the other aforementioned figures, Trčka was shaped by his roots in the traditions of Czech language and culture.

Anton (or Antonín, as his father preferred to call him) Josef Trčka was brought up in a family which had only recently emigrated from Moravia to settle in Vienna. His parents, Josef and Elenora Trčka, both came from families of peasant innkeepers and now ran two small grocery stores — not large businesses, but solid enough to provide a living. This might sound very petit bourgeois, conventional and somewhat dreary. Yet Josef Trčka felt much like the host of others who had moved to this

unloved capital city for purely economic reasons: they never really ceased to feel alien there, nor, thanks to their mother tongue, were they treated as "proper" citizens. Like many others, he was a proud man with nationalistic beliefs, unwilling to accommodate the country's German-speaking culture. On the contrary, living here in the heart of the despised empire which was increasingly viewed by the Czech-speaking intelligentsia as an illegitimate intruder and oppressor, it bordered on a duty to pursue active opposition. The store-keeper refused to let his children — Antonín Josef, Božena and Borivoi (or Boris) were born in rapid succession between 1893 and 1896 in Vienna — be taught at a German-speaking school. (More than 15 years later, and long after Elenora Jerabek had died, another half-brother was born, Swatosch. Once again Josef Trčka had married a woman from his former home country.) There were still no Czech schools — these were to come later, pushed through by the activists organized within cultural associations. So Antonín Josef, the oldest child, was dispatched at the tender age of six to his mother's south Moravian homeland to start primary school.

Thus he grew up in a climate marked by division; he spent his life switching between Czech and German when he was writing; later on, he was trained at the *Höhere Graphische Lehr- und Versuchsanstalt* in Vienna (the so-called *Graphische*, the most celebrated school for graphics throughout the Empire), yet his greatest dream remained to work, or better still to teach, in Prague. Even though the Czech teacher Karel Novák, himself a highly reputed figure in the young Czech republic, had already encouraged him at school and later attempted to prepare the ground for him, this wish remained unfulfilled. He joined an artists' group in Prague, but exhibited with them only once. He worked as a translator, organised readings by Czech authors and became a member of a Czech cultural association, later assuming the position of a functionary. In spite of this, Vienna was and remained (perhaps reluctantly) the centre of ANTIOS' life.

It is then perhaps an irony of fate that in the only academic, institutional appraisal of Trčka's work to date he should have been associated with "Czech Modernism." Josef Kroutvar first presented the artist in the context of this development in an exhibition held in Prague's *Kunstgewerbemuseum* and Vienna's *Museum moderner Kunst* in 1991. I would by no means deny Trčka's proximity to this very distinctive artistic movement which combined an adherence to tradition with a fascination for progress, yet this perspective appears to me to be too restricting. Similarly, it would also be wrong to limit one's view of ANTIOS' work to his relation-

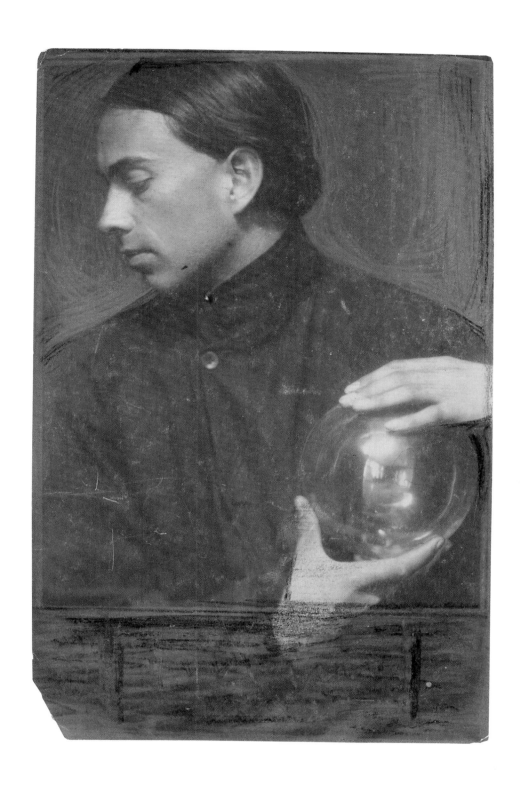

Self-portrait, circa 1914

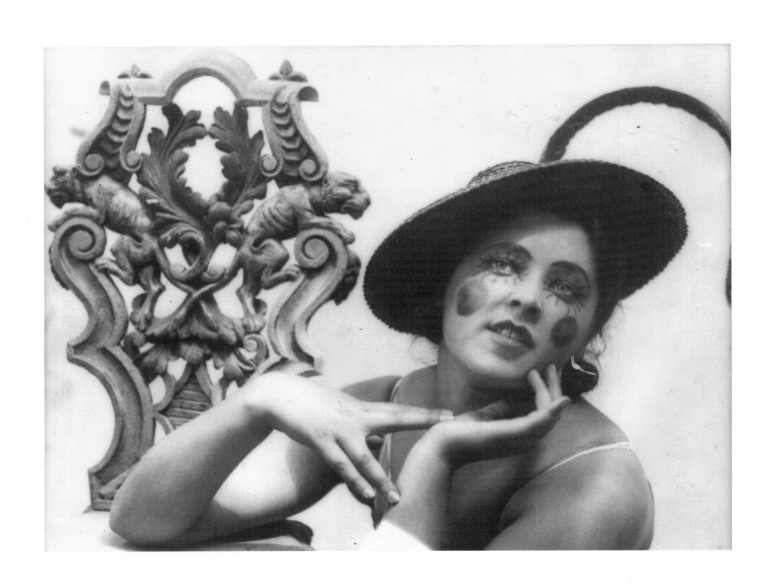

Portrait of the dancer Bertl Komauer, circa 1930

ship with Schiele, and thereby with Vienna. Be it in language, painting or photography, the singularly idiosyncratic position held by Trčka in all these areas (neither easy to consume nor to subsume) can only be properly explained by the course he charted between these two now so familiar circles.

At almost eighteen, Trčka began his training in Vienna in 1911 in the photography class at the *Graphische*, which since its foundation in 1888 had gained a first-class reputation as a "breeding-ground" for exceptionally skilled graduates in all graphic techniques. In the previous year Karel/Carol Novák (born in Horaždovice in 1875 — died in Prague in 1950) had been awarded a teaching post in the photography department; Trčka enrolled with him immediately. Without wishing to oversimplify matters, one might describe Novák's personal photographic style as midway between the early Frantisek Drtikol (particularly the landscapes) and the later Rudolf Dührkoop (in his portraits). His impact on the young ANTIOS (as Trčka started signing all his works from at least 1913 onwards) was both overwhelming and enduring. Indeed, the early group portraits and landscape studies Trčka accomplished as a student not only show similarity in their prevailing symbolist mood, but they also manifest such a high degree of perfection in draughtsmanship, light and shadow composition and technical execution that, for quite some time after they had been discovered amongst Karel Novák's possessions, they were presumed to be works by Novák himself.

Novák's considerable influence also extended to another student at the *Graphische* who didn't enrol until 1912, although he could already look back on years of experience as a photographer — Rudolf Koppitz (born in 1885 in Schreiberseifen near Freudenthal, now called Brumlov, died in 1936 in Vienna). A short excursion into the possible relationship between these two artists might help to shed more light on the biography of ANTIOS which, in the absence of any sound documentary evidence, remains somewhat sparsely documented. Trčka and Koppitz must have known each other, even if there is nothing in writing to prove it. They were both taught at the same time by the same teachers at the *Graphische* (although Koppitz quickly moved up to become an assistant). The early graphic work by Koppitz and Trčka around 1912 is strongly similar in more than just style and thematic focus. Both demonstrate the same concern for contemporary fine art; at that time, such interest was generally encouraged in all students at the *Graphische*, probably by Novák, but in none of the other surviving student work is this interest quite so manifest. Looking at one of the early photographs by Koppitz or ANTIOS, one senses that the textual vignettes

featured in the magazine *Ver Sacrum*, the organ of the Viennese Secessionists, or the applied graphics produced in the *Wiener Werkstätten* are not very far away. This impression is reinforced by their use of bromoil transfer printing which emphasised the photographs' graphic qualities. Also in terms of technical execution and the materials they used (for example, prints on Japanese vellum), they share numerous similarities.

Whether or not they ever re-established contact after their acquaintance was interrupted by the outbreak of the First World War (both served in different sections of the army), remains a matter of conjecture. Certain circumstances suggest that they might have done. Besides their artistic affinity, they also had a common predilection for the "New Dance" movement; both Trčka and Koppitz portrayed the dancers in numerous photographs, especially in the period around 1926. Some of them, such as Gertrud Bodenwieser, even modelled for both photographers. In retrospect, certain factors are almost impossible to assess: for instance, although Koppitz originated from Moravia, he was nonetheless brought up speaking German and didn't identify with the Czech nation. Nor did he ever give the slightest hint that he wished to return to the "land of his fathers." (Incidentally, his family were extremely poor, much poorer than Trčka's forebears.) The racial-cultural composition and structure of the monarchy was highly complex, hence generalised statements about specific regions are often misguided. What Trčka's attitude to such a compatriot might have been can only be guessed at.

But considering the different courses their careers took after 1918, the likelihood of continued contact between the two men seems rather slim. Koppitz went on to become a distinguished teacher at the *Graphische* an influential functionary within the photographers' guild and a regular prize-winner of innumerable exhibitions of "artistic photography" in Europe and abroad. Trčka, on the other hand, always remained an outsider, forever denied financial success and recognition both in his photography (which he began to practise commercially in the twenties) and in his painting, which periodically became the main focus of his artistic endeavours.

Around 1914 ANTIOS met Egon Schiele. Although their collaboration on the portraits lasted only a matter of weeks, they maintained contact up till Schiele's death in 1918. He recommended the young photographer to others such as Gustav Klimt, who in turn probably recommended him to Peter Altenberg. In spite of his constantly strapped financial situation, Trčka until his death refused almost without excep-

tion to sell off the drawings and paintings he had received from these and other artist-clients in exchange for his photographs.

He travelled regularly back to his family's country, where he drew and painted small-scale landscape watercolours. And it was here in 1916 that he first made contact with Rudolf Steiner and the Czech poet, Otakar Březina—an encounter which had overwhelming and incisive impact. In Vienna he had already become acquainted with the now famous poet, Josef Svatopluk Machar (photographing him in 1914) who, like Březina, had been a signatory of the "Modernist" manifesto in the last decade of the previous century. When Machar returned to Prague in 1919, Trčka solicited his support in his attempt to move there too. It was probably in the circle surrounding the poet that he also met those artists with whom he was later (in 1923) to share an exhibition titled *Die Unentwegten* (The Stalwarts) in the Rudolfinum in Prague. In 1910 some of them—including Jan Konupek and Jan Zrzavy—had already founded the artists' group *Sursum*, with their expressively symbolist graphics combining various elements drawn from folklore and mysticism. It is perhaps here that we find the most important roots for Trčka's painting style in the period between 1918 and 1920, before he went on to commit himself wholly to anthroposophic pastels.

During the war Trčka served in the Austrian forces, but demobbed in the newly-formed Czech army. In the meantime he had married in Vienna: Clara Schlesinger, a Viennese artist of Jewish origin who shared her husband's enthusiasm for Rudolf Steiner. Trčka saw himself as belonging to a colony of artists which had installed itself in a still relatively rural outlying district of Vienna. Without any prospects of work he didn't wish to risk a move to Prague, and chose to adopt Austrian nationality. His father and sister died in 1920 and his marriage was beset with problems. In spite of the birth of a daughter, it was not to last long. By then Trčka had already started to pursue poetry, painting and photography concurrently. While his paintings were on show in the celebrated Viennese *Hagenbund* in 1924, he was at the same time also trying to achieve commercial success as a photographer. He founded the *Ringwerkstätten für Kunsthandwerk und Lichtbildkunst*, a studio for arts, crafts and photography. A number of his photographs chosen for the exhibition in Hanover bear the studio's official stamp, but these represent only a small sample from the broad spectrum of work by ANTIOS. The selection of exhibits attempts to highlight the artist's very individual treatment of the human image, an approach which constantly emphasises expressive gesture—this is manifest not only in his pictures of the dancers and nudes, but also in the majority of his portraits. Unmatched in the

photography of that period, Trčka's work possesses a flowing rhythm and a graphic dynamism which he achieved through the combination of various elements: the attitudes of face and hands, the painted or arranged backgrounds (most of the props were in fact made by the artist himself) and the decorative lettering, an essential component of the overall composition. His work certainly cannot be judged according to the criteria of the "avant-garde" or the conditions set by the "new vision" movement which still govern our image of the photography of the twenties. At the same time, nor can his photographs be seen as a belated derivative of art nouveau and symbolism, since they would have been inconceivable twenty years earlier.

While most of the portraits, nudes and dancers which have survived were made in the mid-twenties, the losses incurred by the destruction of his studio during the Second World War make it near impossible to estimate the total volume of photographic work ANTIOS actually accomplished. Surviving drafts of letters and notes scribbled on the backs of photographs and drawings indicate that he was also privately befriended with several of his models, notably the poets Robert Michel and Jakub Deml. With the dancers of the "Eurhythmic Group" he photographed on various occasions, he certainly shared a common enthusiasm for anthroposophy which was to influence his work to an increasing extent. From 1930 onwards, he spent almost all his time penning lengthy poetic epics of a mystical and visionary character. (Excerpts of these are to be published for the first time in conjunction with a comprehensive exhibition, which will also include paintings by Trčka, to be held in the Rupertinum in Salzburg in 1999.) Furthermore, on a regular basis he personally (as can be seen from the surviving invitation cards) organised lectures and readings in his studio from the works of Otakar Březina, Jakub Deml and poets close to the Anthroposophical Society.

It seems he more or less scraped a living mainly from dealing in antiques. And he appears to have resumed his activity in the Czech cultural association in Vienna. Maybe this was what interested the STAPO (state police) when they summonsed him for an interview in February 1940. We have no information relating to this. Three weeks later Antonín Josef Trčka was found dead in his flat; the autopsy established the cause as carbon monoxide poisoning due to leaking coal gas. Two death notices were printed — one in German, one in Czech.

Translation Matthew Partridge

Anton Josef Trčka

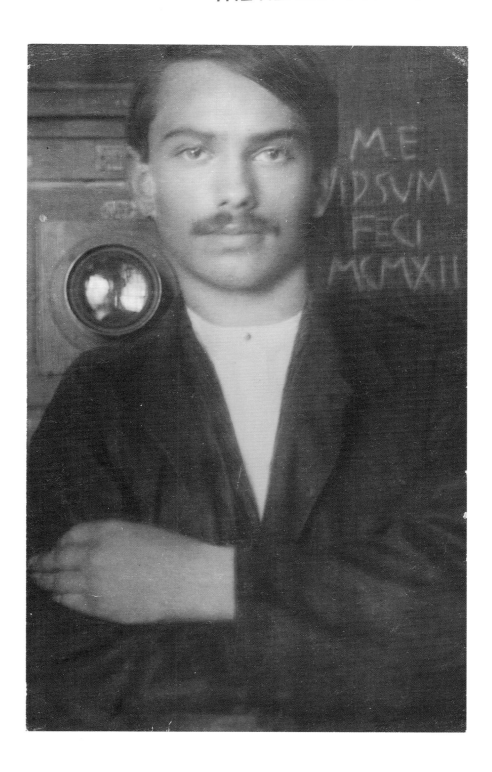

Self-portrait with camera, 1912

Portrait of the photographer's sister Božena, 1912

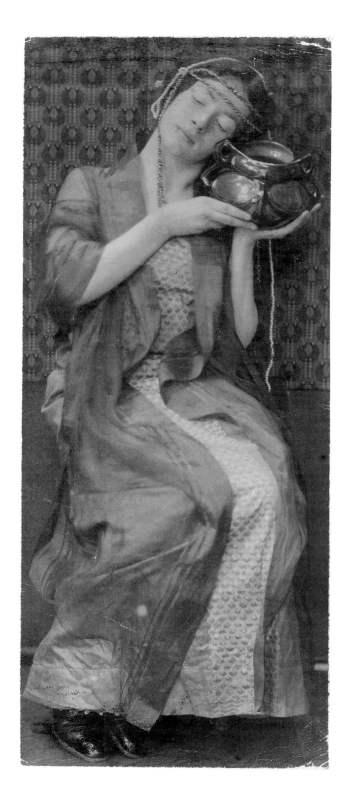

Portrait of the photographer's sister Božena, circa 1913

Self-portrait with painting, 1913

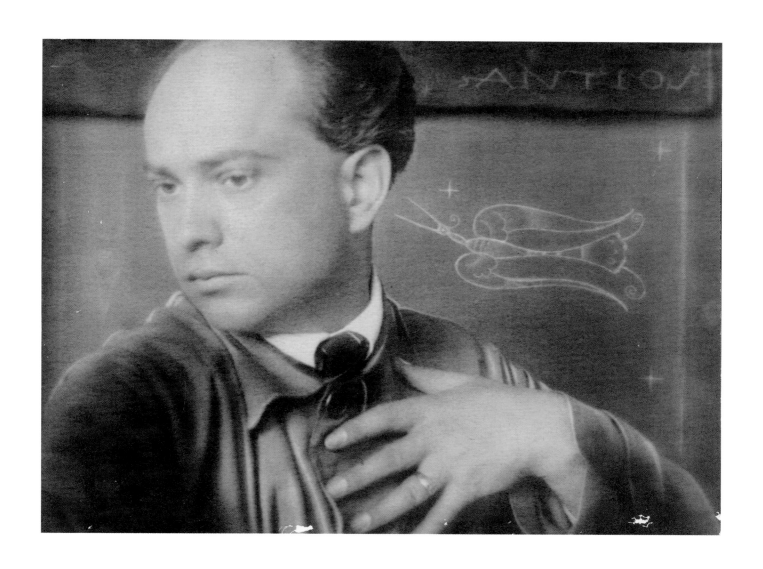

Self-portrait with bird, 1926

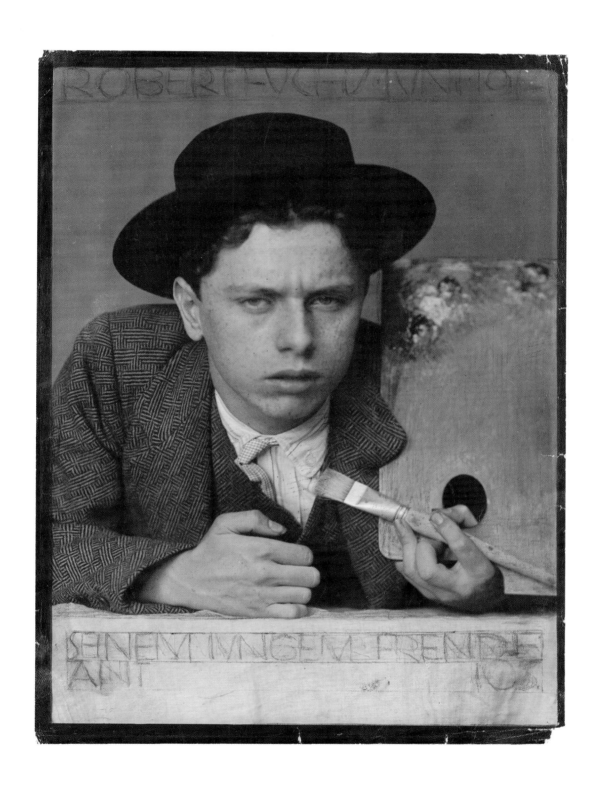

Portrait of the painter Robert Fuchs, 1914

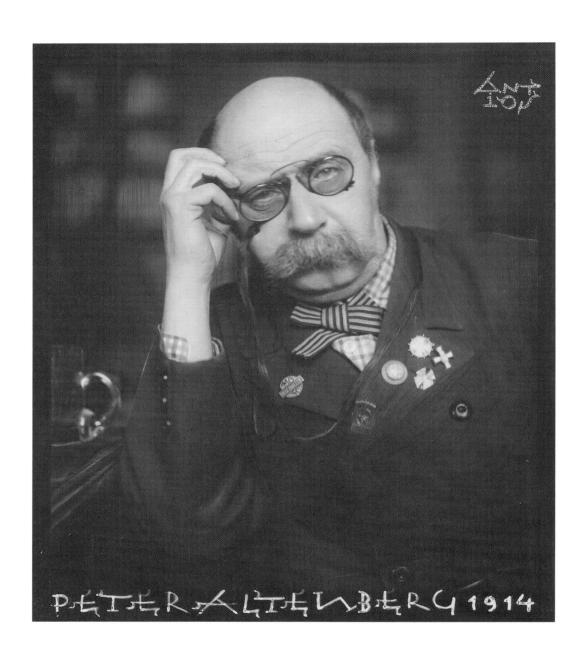

Portrait of the poet Peter Altenberg, 1914

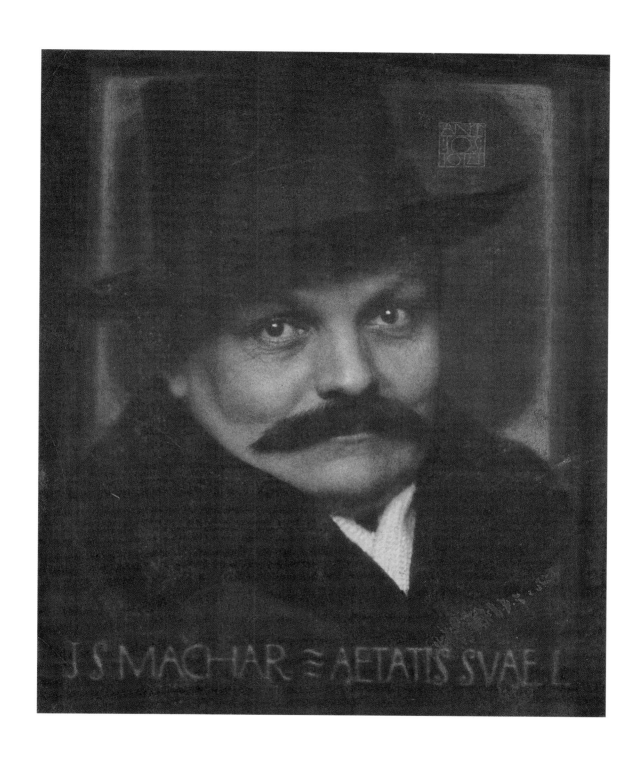

Portrait of the poet Josef Machar, 1914

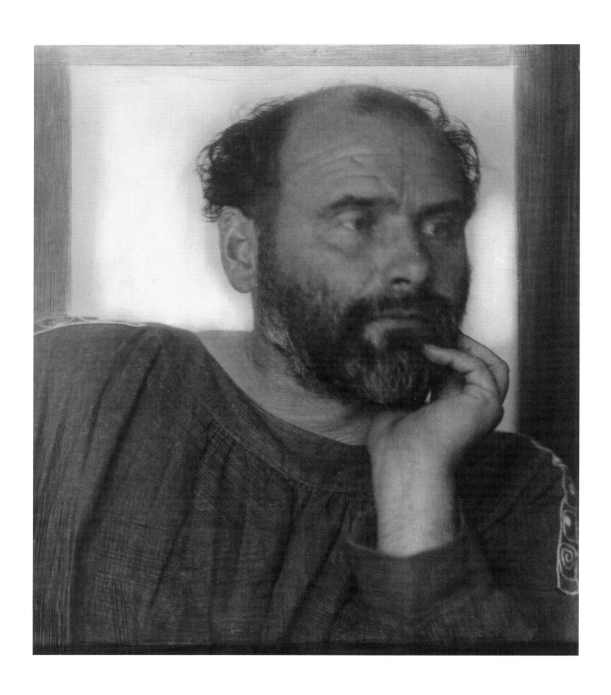

Portrait of the painter Gustav Klimt, 1914

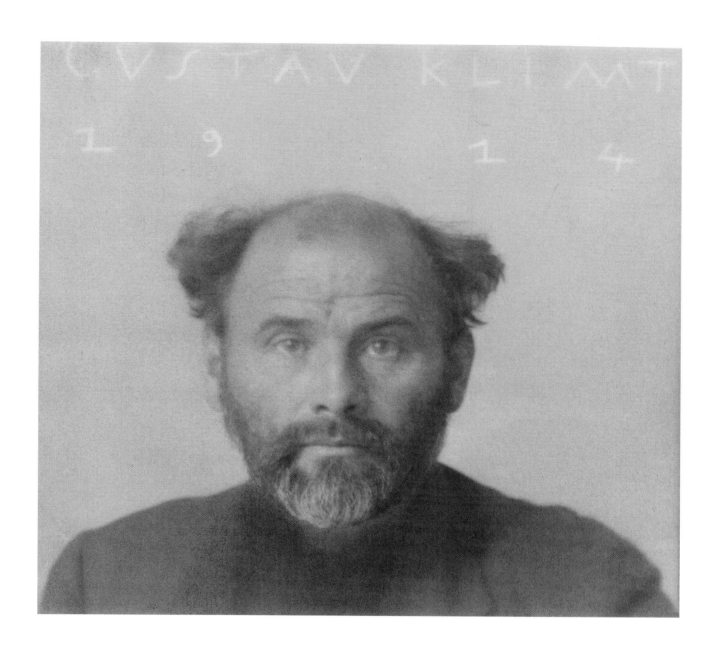

Portrait of the painter Gustav Klimt, 1914

Portrait of the painter Egon Schiele, 1914

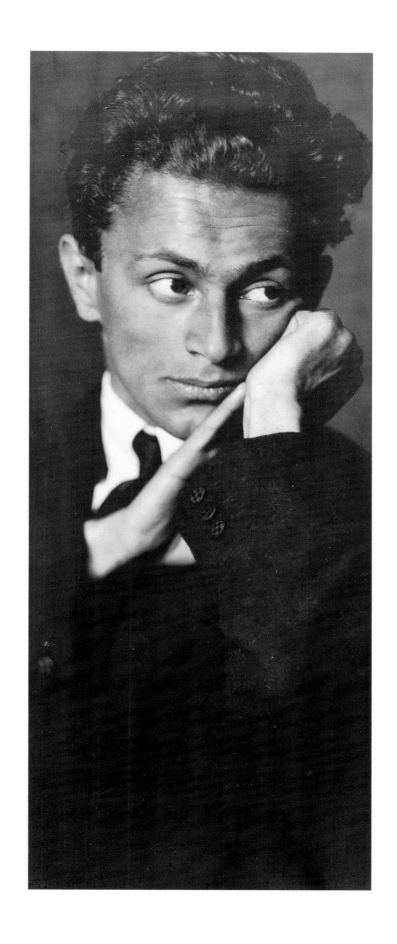

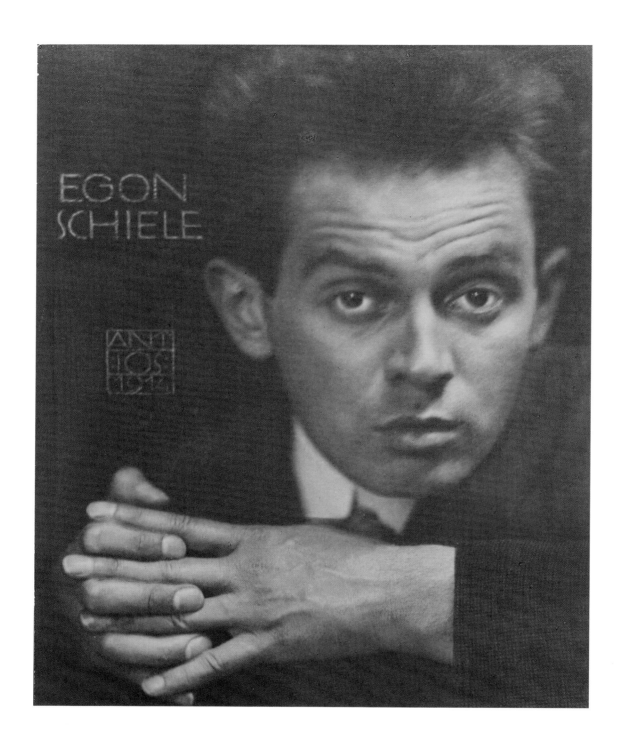

Portrait of the painter Egon Schiele, 1914

42

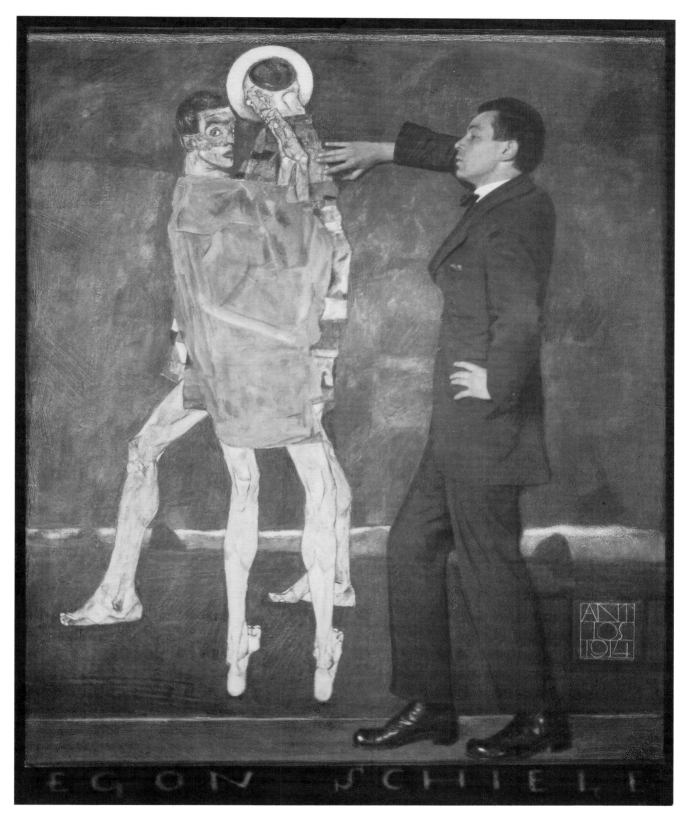

Portrait of the painter Egon Schiele with painting, 1914

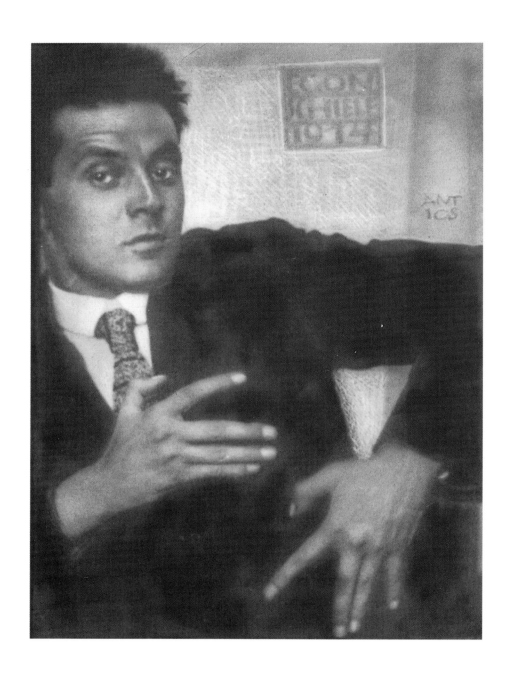

Portrait of the painter Egon Schiele, 1914

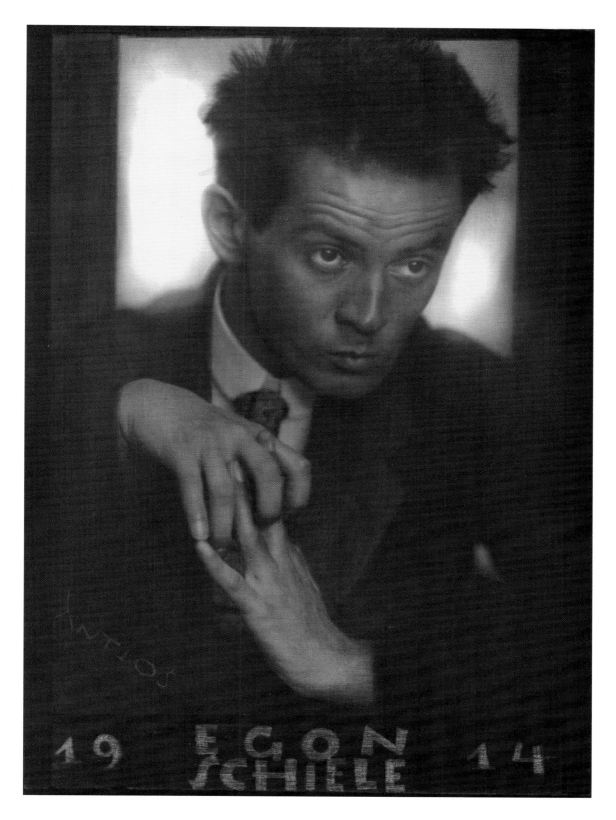

Portrait of the painter Egon Schiele, 1914

Cat, circa 1925

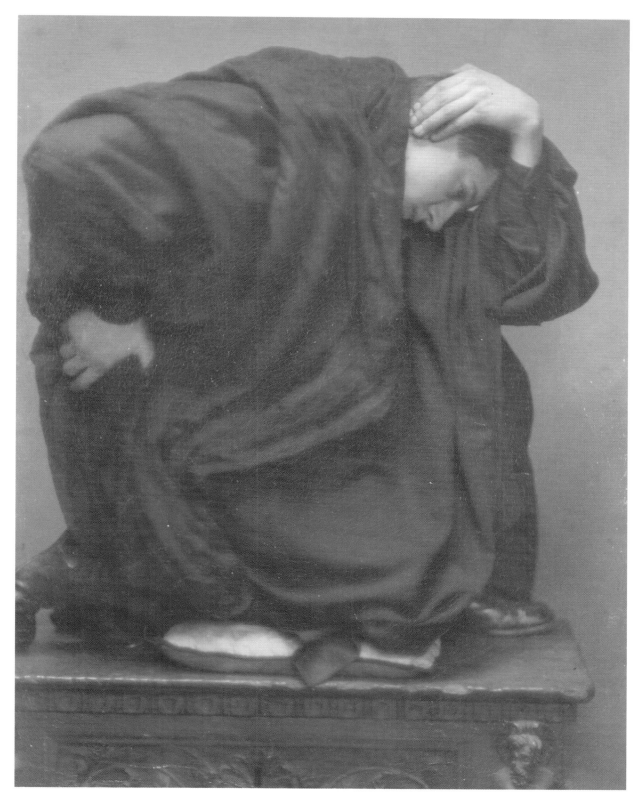

Dancer, circa 1925

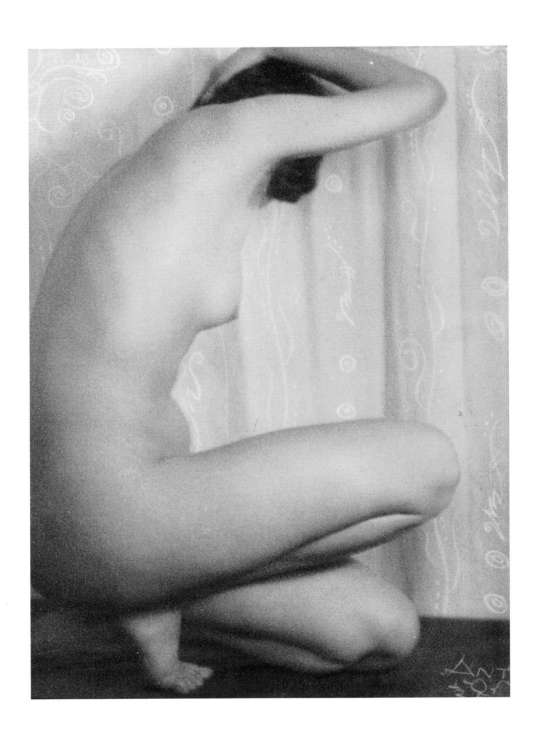

Nude squatting, circa 1925

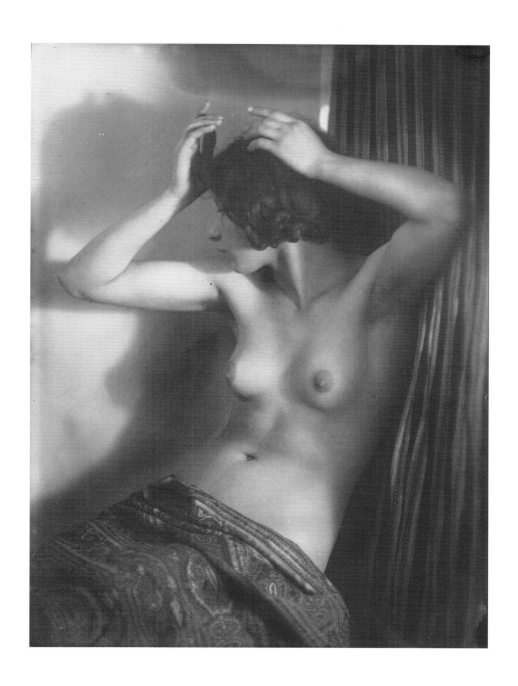

Semi-nude with raised arms, circa 1925

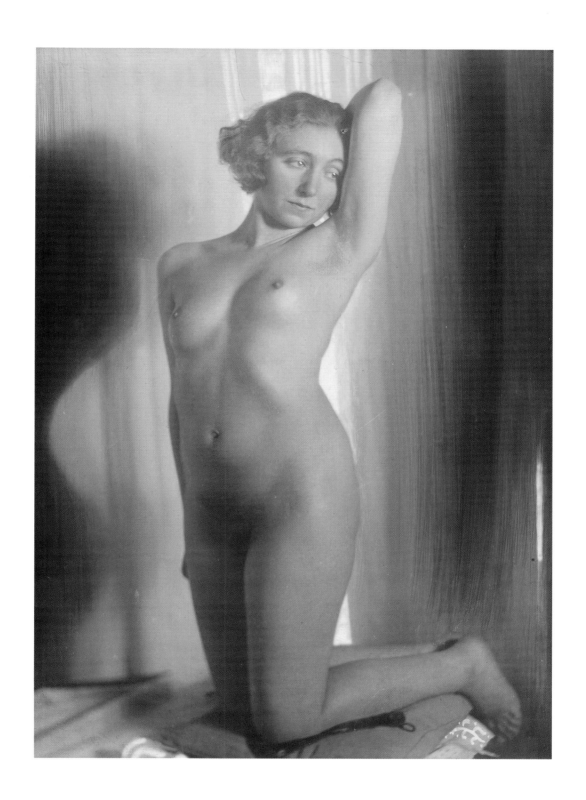

Nude kneeling, circa 1925

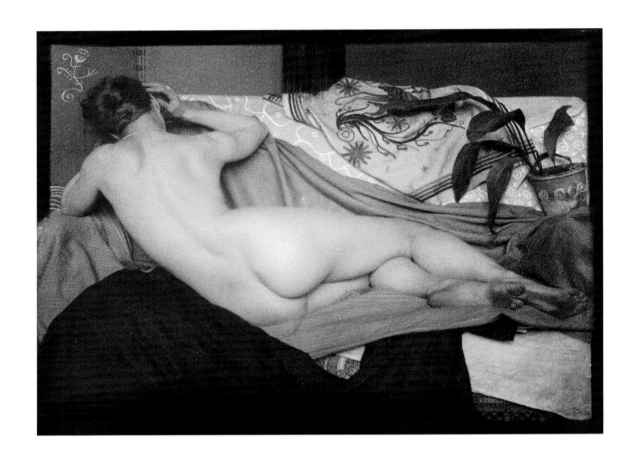

Naked back, circa 1925

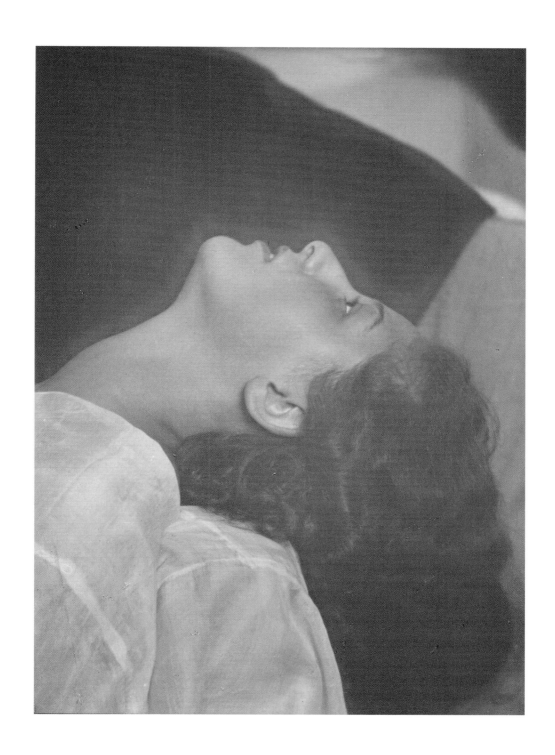

Portrait of a woman in profile, circa 1925

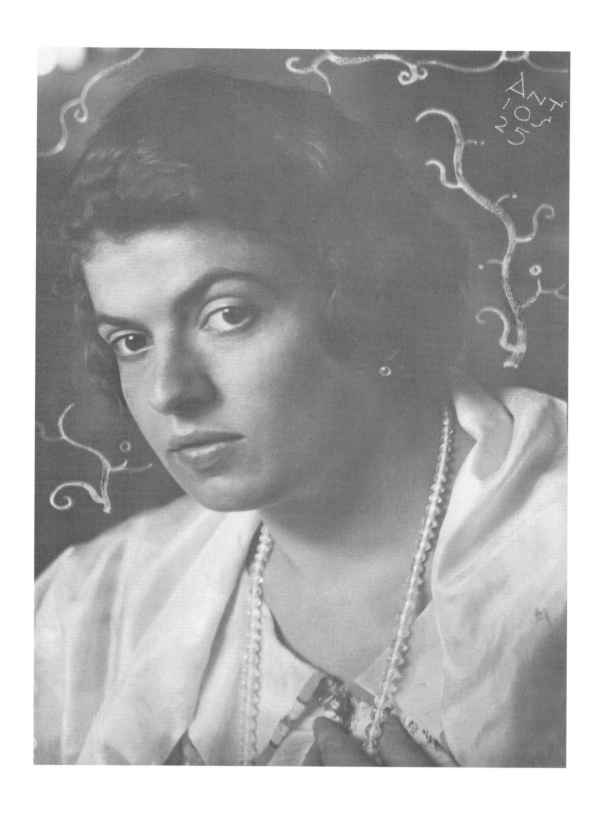

Portrait of the photographer's sister-in-law, Olga Trčka, 1925

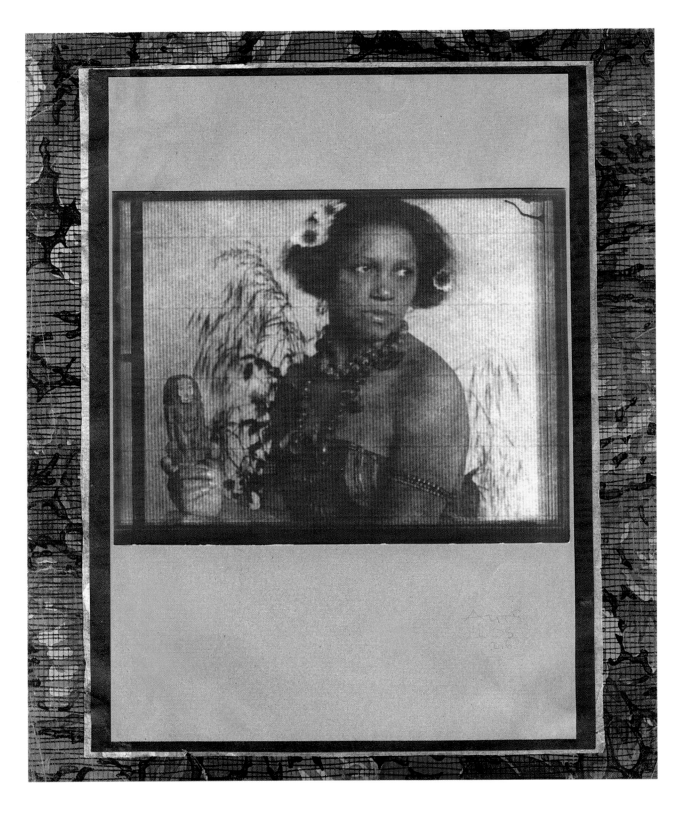

Portrait of a woman on a colourful surface, circa 1925

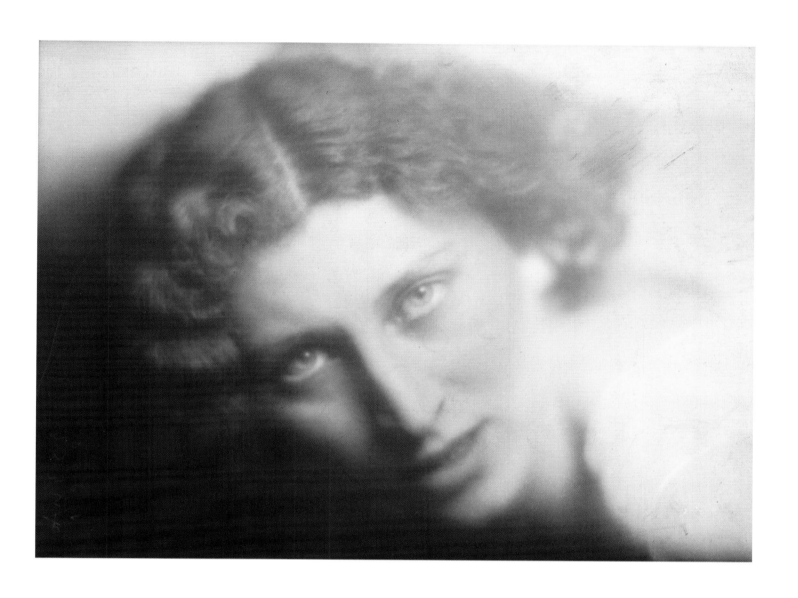

Portrait of the dancer Hilde Holger, 1925

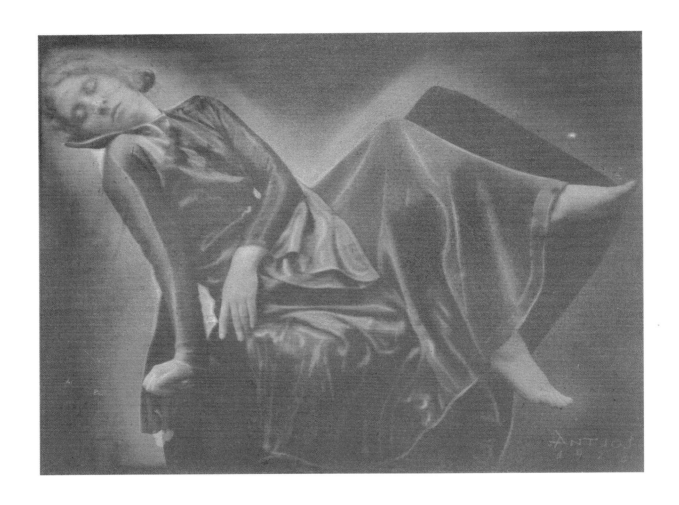

Portrait of the dancer Hilde Holger, 1925 | Dancer of the Bodenwieser school, circa 1925 ▶

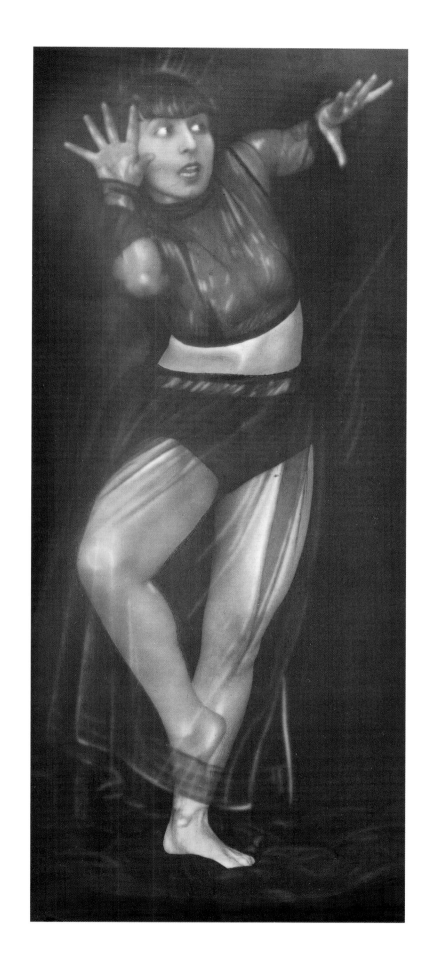

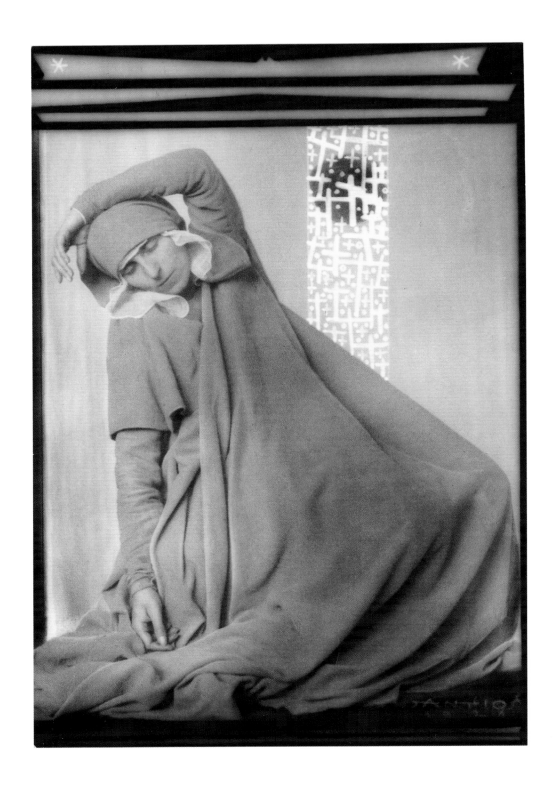

The dancer Elinor Tordis wearing a nun's habit, 1926 | Hilde Holger outdoors, circa 1925 ▶

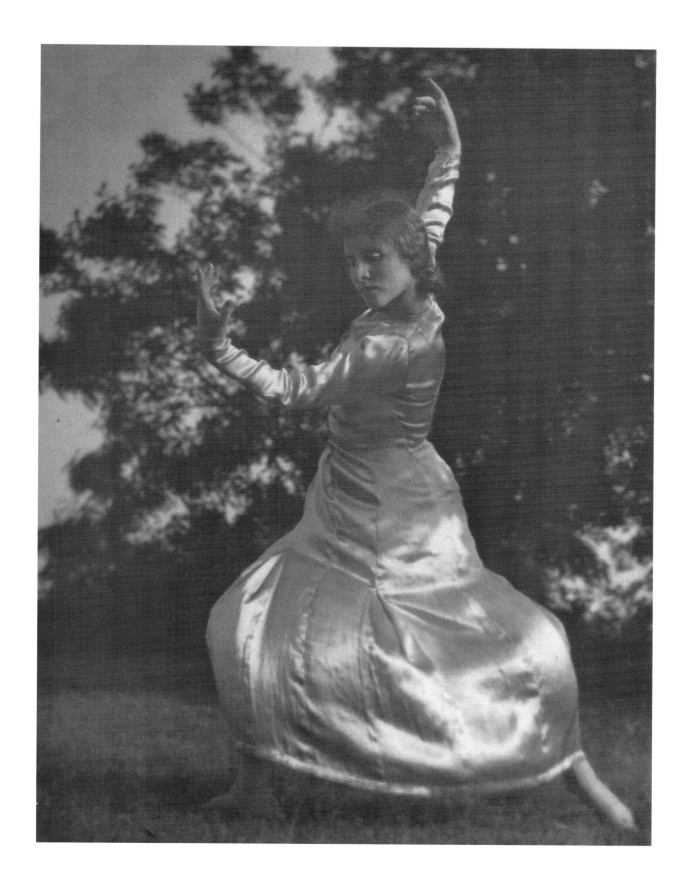

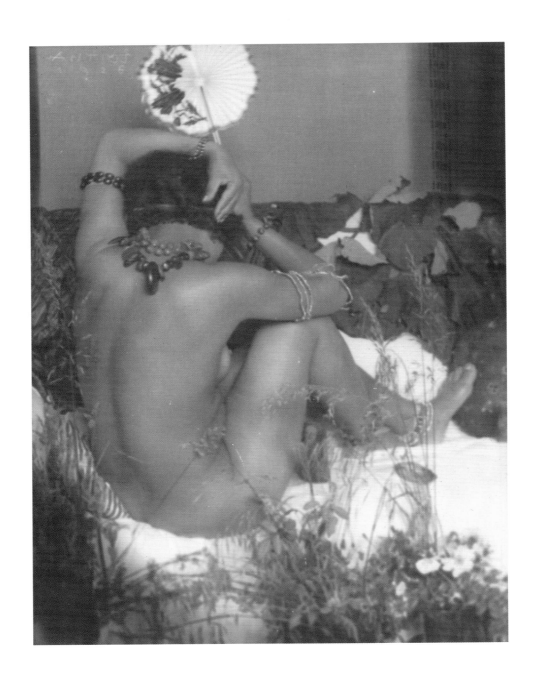

Semi-nude from behind with fan, circa 1925

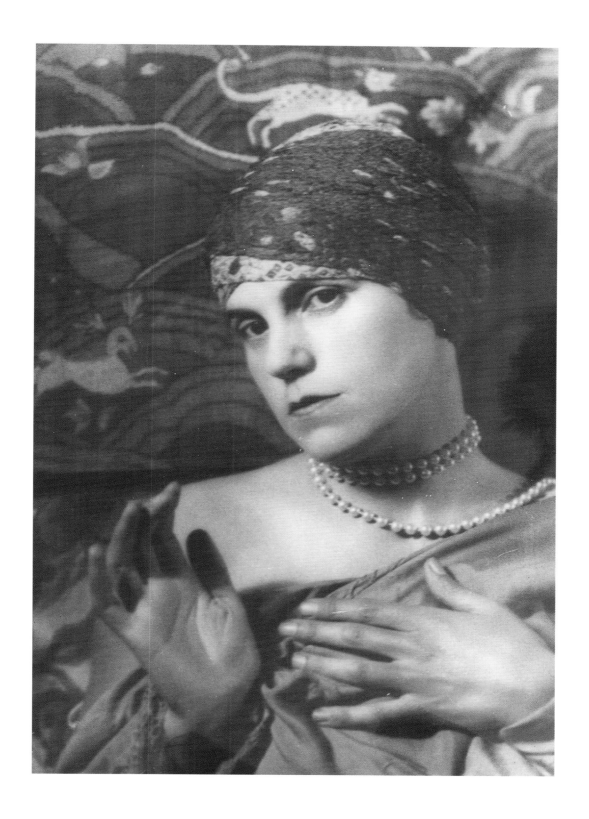

Woman wearing a turban, circa 1928

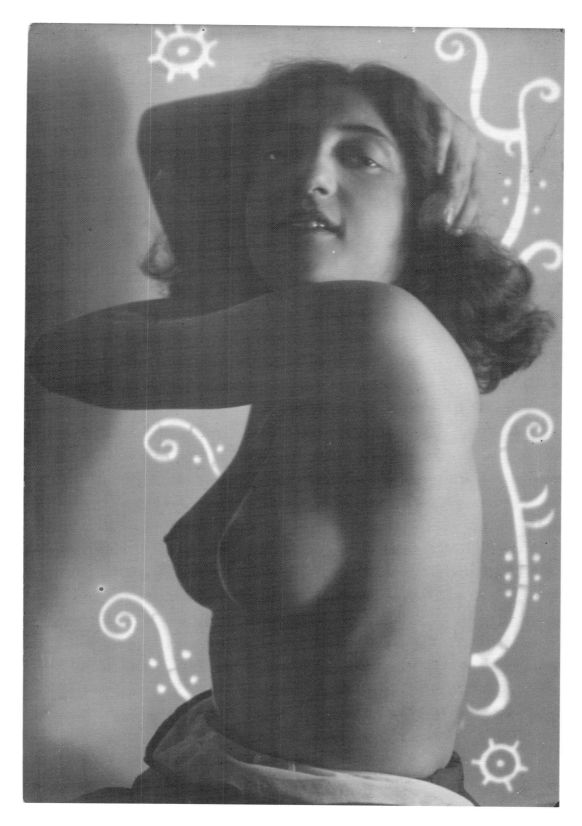

Semi-nude, circa 1927

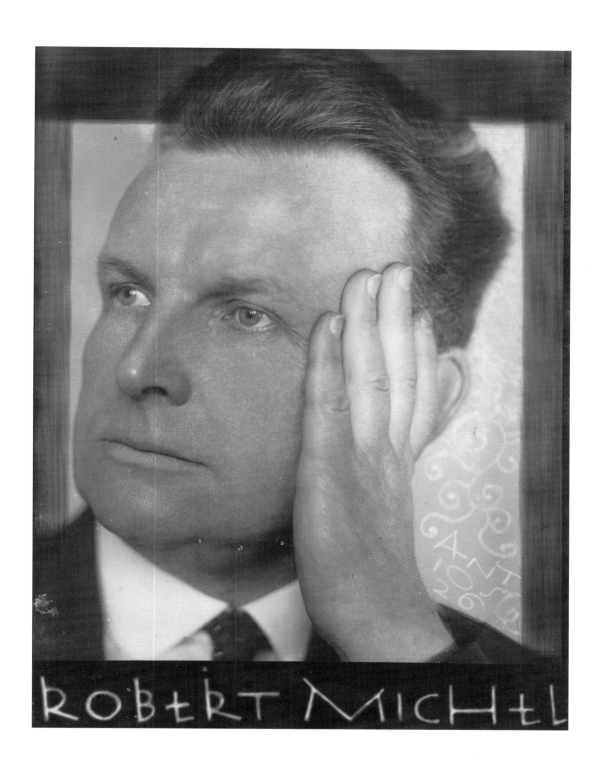

Portrait of the poet Robert Michel, 1926

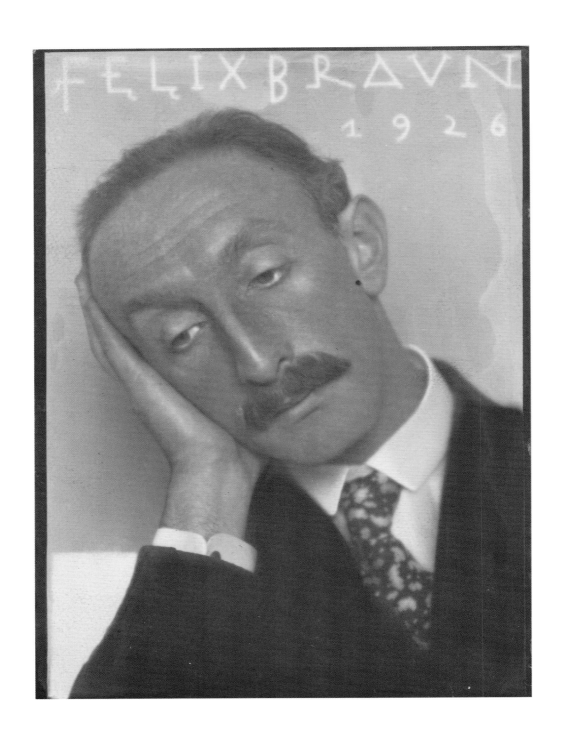

Portrait of the poet Felix Braun, 1926

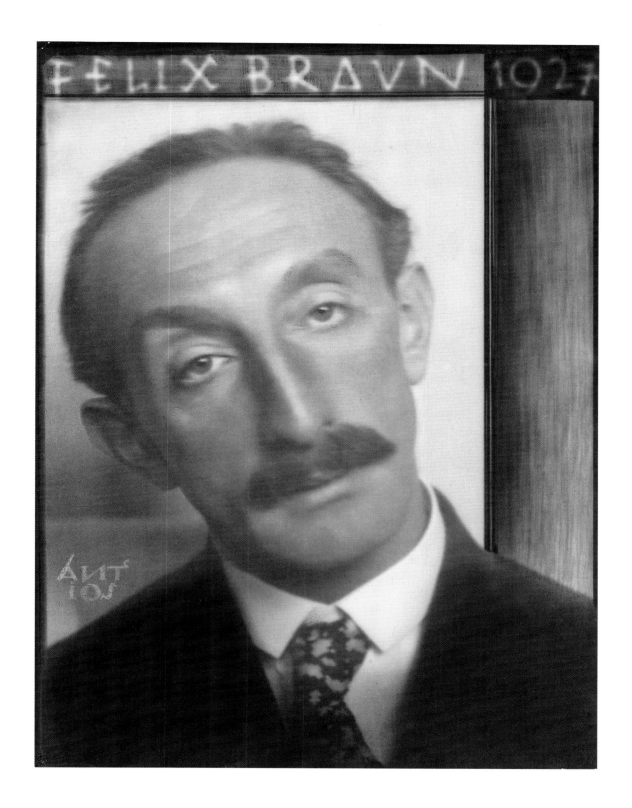

Portrait of the poet Felix Braun, 1927

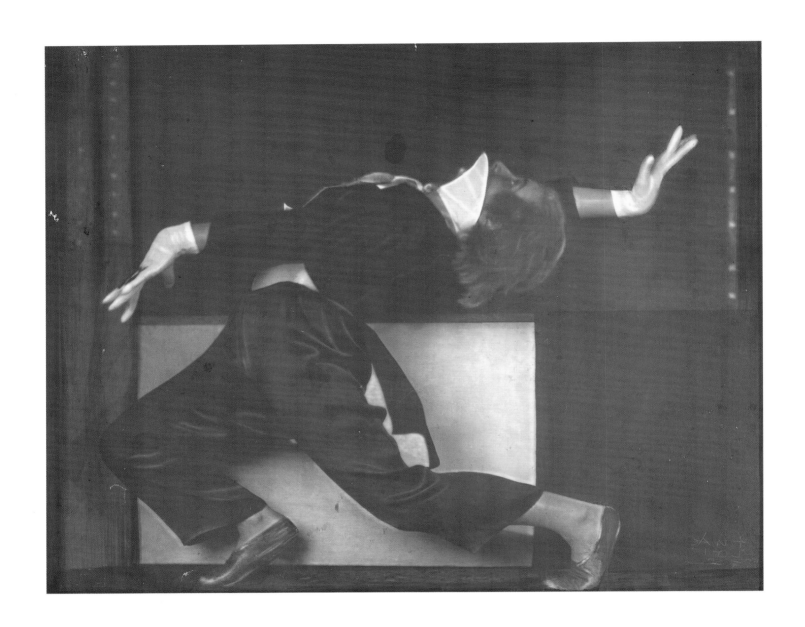

Hilde Holger (?) wearing a white collar, circa 1928

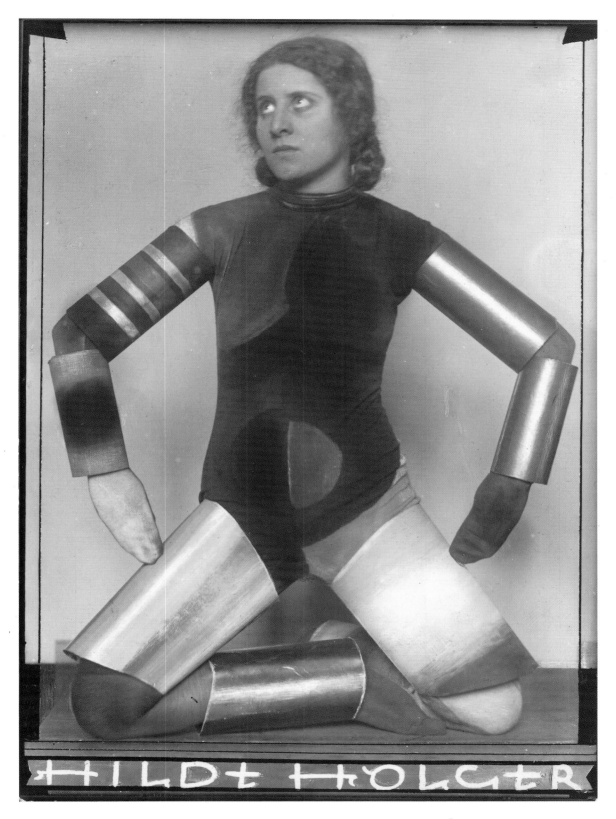

Hilde Holger wearing a metal costume, circa 1928

73

"Photography ... sees more than the eye sees."

Edward Weston

Weston's Gaze — On the Moments of Photography

A photographic cosmos

by Carsten Ahrens

The body of a naked woman, a pepper, the root of a tree, a shell, a face, a sand-duned landscape, a radish, a toilet bowl, a cauliflower, a canyon — the subject matter in Edward Weston's work is as wide-ranging as it is diverse. The list has an indiscriminate ring to it, but his photographic signature is unmistakable throughout. More than almost any other photographer of the period, Edward Weston used his camera to explore elementary form in search of photography's authentic expression as an artistic medium. As was happening at that time in other fields of the fine arts, such as painting and sculpture, photographers too were striving after that utopian vanishing point of an autonomous artistic language embodied in the concept of "pure photography." Edward Weston was one of the most outstanding pioneers of this process, which from the very outset was an artistic endeavour. The modernist movement's slogan of "the medium is the message" became a key principle in Weston's approach, providing the conceptual basis for his photographic work. Disregarding ideological theorems, he trusted entirely in the visionary capacity of photography and the camera's technical potential. In this, he was able to depend on the precision of his craftsmanship and on the intuition of the moment. Weston sought a communion of the artist's eye and the optical powers of the lens. He placed emphasis on that coincidence of artist and camera which is so neatly expressed in the pun "Camera I,"

a cooperative intimacy which was congenially caught in a photograph by Tina Modotti, Weston's partner over many years. Shot in 1924, the picture portrays Edward Weston bearing that look of unwavering resolution with which he pursued his purpose. The fields of vision of both artist and camera appear to converge along close parallel lines — attentively, inquisitively and penetratingly, an object is held in focus in one shared and intense moment of perception.

More eloquent than a thousand words, this photograph describes the rigorous passion of a man whose artistic career was from the start governed by the dream of making photography a medium of direct and unmanipulated artistic expression.

As it was, the course of Weston's existence was beset with twists and turns. On the surface of everyday life, things were exceedingly turbulent; the conditions in which he lived, his relationships, everything was in continual flux. Notwithstanding, Weston pursued his artistic aim of pure photography as an authentic expression of life with unflagging persistence.

The start of this ramified path is signalled by a gift, one which was also to become a gift to twentieth-century art. In the summer of 1902 Weston was given a camera by his father. The present was accompanied by a letter in which the father admonished his son to make profitable use of the device. He recommended him to take snapshots of memorable occasions and not to waste pictures on things of no consequence. Paradoxically, this paternal guidance must have been pure encouragement for young Edward Weston's inquisitive nature. The warning inspired him to explore the camera's possibilities and to start experimenting with aimless curiosity. The foundations were laid: his interest in the medium had been kindled, and from then on he concentrated solely on evolving a language of photography as a means of artistic expression. "I see no reasons for recording the obvious," Weston was later to say.

The exposure of life's quintessence as contained in reality's most basic phenomena became the daunting task Weston took upon himself, and he went about it in the manner of a scientist. He painstakingly registered the results of apertures and developing times, keeping records about the effects he achieved using different types of paper — in short, he investigated all aspects of his craft with the aim of precisely calculating what should happen at the moment of exposure. From this point on he was driven by the wish to become entirely conversant with the camera. For once the shutter has been released — thus the purist credo — no subsequent

changes were allowed. Retouching negatives or manipulating prints was deemed inconceivable in the semantic system of authentic photography.

The mystery exuded by Edward Weston's photographs lies precisely in this insistence upon accuracy. The proportional clarity, the minutely etched texture of surfaces caught by the light, the sharp contours, echoing in their linear rhythm the movement of the fleeting moment, the palpable materiality of the surfaces—these qualities would be unthinkable without this unerring degree of precision. Then there are the diaries full of Weston's accounts of moments of failure—inattentiveness, wrong decisions at crucial moments—such descriptions all speak volumes about the complexity of his task.

"Photography's great difficulty," Weston summarised in 1930, "lies in the necessary coincidence of the sitter's revealment, the photographer's realization, the camera's readiness. But when these elements do coincide ... when the perfect spontaneous union is consummated ... the very bones of life are bared."

It was in 1907 that Edward Weston, having moved to California at short notice, finally decided to turn his love of photography into his profession. He enrolled at the Illinois College of Photography in Chicago, acquired the requisite skills and then returned to California, where he worked in various photo studios. In 1911, after his marriage to Flora Chandler whom he had met in 1907, he set up his own studio for portrait photography in Tropico (now called Glendale), a suburb of Los Angeles. Even then he boasted that his portraits never needed retouching. However, it was one matter to maintain a family which had quickly expanded to include four children, but quite another to sustain the artistic ambitions of Edward Weston. He took keen interest in the latest developments in the field of artistic photography. His ideas were increasingly influenced by the New York magazine *Camera Work*, published by Alfred Stieglitz, the innovative figurehead of the new photography movement. In Los Angeles Weston gradually began to establish himself and he achieved his first successes. He started off by photographing in the prevailing contemporary style of pictorialism. Reality was enigmatically transformed, and a tangible demonstration of the artistic possibilities of the photographic image was provided by quasi-constructivist backgrounds, tipped angles, the construed interplay of light and shadow, and veils of atmospheric translucence through which the scenic arrangements vibrantly shimmered. But although Weston achieved initial success with these pictures, he soon began to feel that this approach would lead nowhere.

As early as 1916 he had written about the future of his own photography, a strategy he was indeed soon to take up. "I experimented with all shades of focus and deliberate over- and under-exposure in order to get certain effects, until I came to realize what photography is actually all about," he wrote in 1921.

What fundamentally changed was his handling of the camera. It was no longer used to artistically cast reality in a different light, but was employed as an alternative and more accurate kind of eye, an instrument capable of extending the range of human sight. The "new photography" (or "straight photography") emerged as an immediate dialogue between the eye and the lens.

Weston must have felt quite confident about his artistic concept when, in 1922, he arranged to meet Alfred Stieglitz, the father-figure of modern American photography. During the four-hour conversation held in New York, Stieglitz philosophised in general terms about the future of photography, also criticising several photos Weston had brought to show him. On many counts the verdict pronounced by the maestro was severe, but Weston could no longer be deterred from his undertaking — Stieglitz's criticism only further encouraged him to pursue his chosen path.

Indeed, in a variety of aspects he was increasingly moving away from the main representatives of modern American photography. For, unlike Charles Sheeler or Walker Evans, Weston's interest in the "straight photography" movement seldom involved the appeal of the typical subjects which formed the movement's aesthetic agenda: urban scenes of the metropolis and the pulse of technology, breathtaking linear perspectives of skyscrapers, bridges and industrial plants. And so it was perhaps no coincidence that he shot the series in Middletown's Armco Steel Mill when on the way to meet Stieglitz in New York — almost as if he needed to offer proof of his proficiency in this terrain. Yet his attention was increasingly drawn to nature in all its manifestations. In fact for Weston, the idea of definitive or favoured motifs ceased to be valid from that point onwards. In his eyes, everything now had the status of potential subject matter. His interest in the subject gave way to a preoccupation with the manner in which a picture was produced; the central focus of his work had now shifted from the object to the photographically observed form.

This change in orientation was part of a broader process of renewal. In Los Angeles Weston had got to know Tina Modotti, who was soon to become his model, his lover and finally his partner. He went to Mexico with her. In this period his artistic signature gained increasing definition. But even though his friends, among them the painters Rivera and Siqueiros, celebrated Mexico as a paradise for artists, Weston was

unable to establish himself there — especially in financial terms. He commuted constantly between Mexico and California before returning to live in Glendale in 1927, and two years later he moved to Carmel and the solitude of the mountains north of Los Angeles. In this period he evolved his concept: the need to photographically "sublimate things seen into things known."

Weston's photography gives expression to the comprehensive unity of all phenomena. In the microscopic world of the close-up, forms manifest themselves whose provenance cannot be definitively established. Micro- and macrocosms interchange, everything seems to be swept along in a singular movement. The relativity of all existence finds visible shape in the artificial character of reality represented in Weston's photographs.

"I have come to realize life as a coherent whole, and myself as a part, with rocks, trees, bones, cabbages, smokestacks, torsos, all interrelated, interdependent — each a symbol of the whole. And further, details of these parts have their own integrity, and through them the whole is indicated, so that a pebble becomes a mountain, a twig is seen as a tree." (1930)

In the elementary forms which from then on assume centre stage in Weston's pictures, anthropomorphic structures are continually rendered visible. In the same way that some of his nudes take on the appearance of plant life, shells or even vases, mineral or organic forms inversely exhibit certain traits of the human body. Whatever the photographs depict, they are characterised by a penetrating and vital physicality. The represented object is suggestively attributed a physical presence which, at the moment of exposure, seems to reproduce the presence of the artist. This was how Tina Modotti responded to a photo series of shells which Weston made in 1927 and sent to her in Mexico. In a letter to him she wrote: "Your last pictures were breathtaking. I sit speechless before them. What purity of vision. After I opened the packet, I couldn't look at them for long. They disturb me not only mentally, but physically too. They are mysterious and erotic."

There is a conspicuous resemblance between these forms, for example, and the sculptural inventions of Louise Bourgeois, if one compares, say, her works showing female breasts serially multiplied in endless rows to Weston's photographs of the seemingly mundane cauliflower.

Weston always took exception to sexual interpretations of his universe of forms; he obviously felt this view of things to be too one-sided, especially since his personal life was not infrequently subjected to short-sighted psychological commen-

tary based on his works. Understandably, there was nothing he detested more than having personal details intrude into the lucid world of his abstract pictorial forms. Nevertheless, he did deem the general curiosity about his relationship to his models — whether they were peppers or actual naked women — to be worthy of comment: "It has been suggested that I am a cannibal who eats his models in a masterpiece! But I prefer the idea that they become a part of me, enrich my blood as well as my vision."

In fact, his models, girlfriends or partners, be it Tina Modotti or Sonya Noskowiak, Henrietta Shore or his wife for many years, Charis Wilson, were to a greater or lesser degree all influential in the progress of his photographic work towards a language of abstract art. As early as 1930 Weston jotted down the words "modern classicism" on one of the *Excusado* prints. His works of the late twenties and thirties do indeed feel like timeless reflections of the world which with vital energy manifest the essential substance of things through the abstract beauty of formal clarity. In the artificial stylisation which is generated entirely from the fragmented and precise vision of Weston's photographs, there emerges a picture of a universal world order, lent discernible shape through the formal language of art.

Or, as Edward Weston himself maintains: "Actually, I have proved through photography, that nature has all the abstract (simplified) forms that Brancusi, or any other artist, could imagine. With my camera I go direct to Brancusi's 'source.' I find *ready to use* — select and isolate — what he has to *create*."

Translation Matthew Partridge

Edward Weston

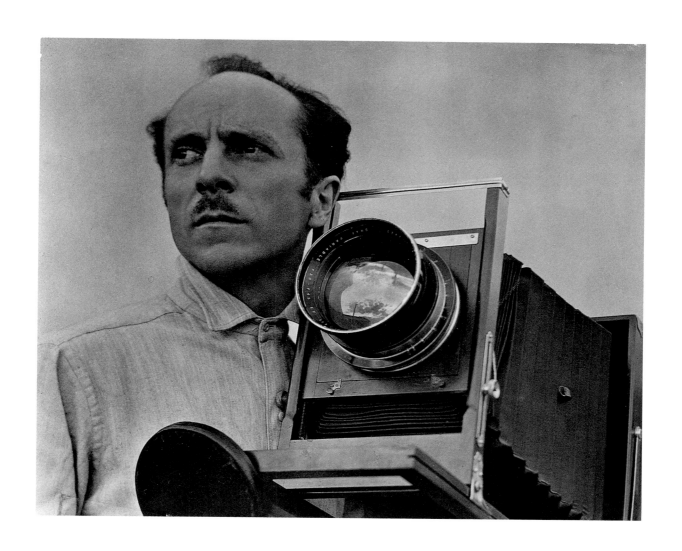

Tina Modotti: Edward Weston with Seneca View Camera, circa 1924

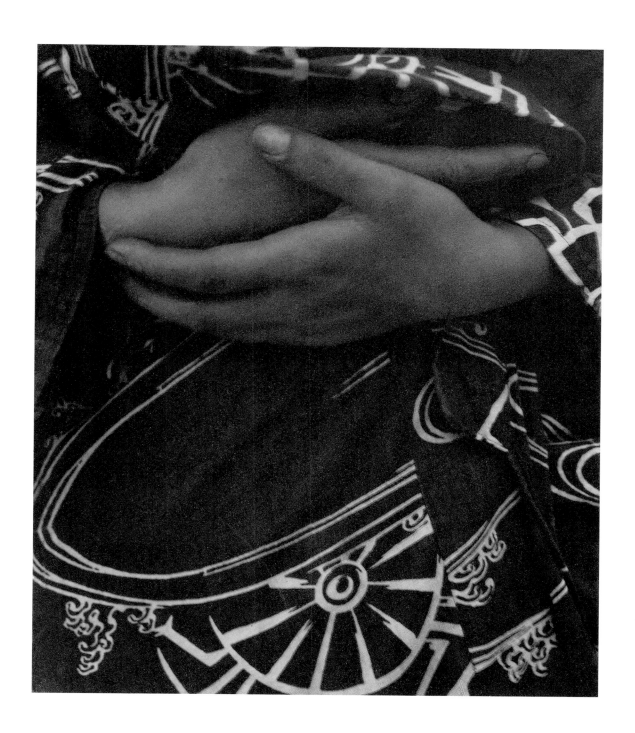

Hands against Kimono (Tina Modotti), 1923

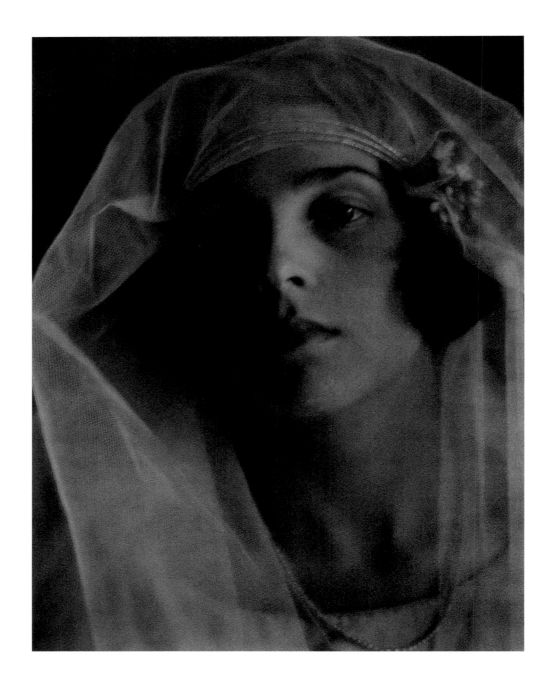

Bride, circa 1920

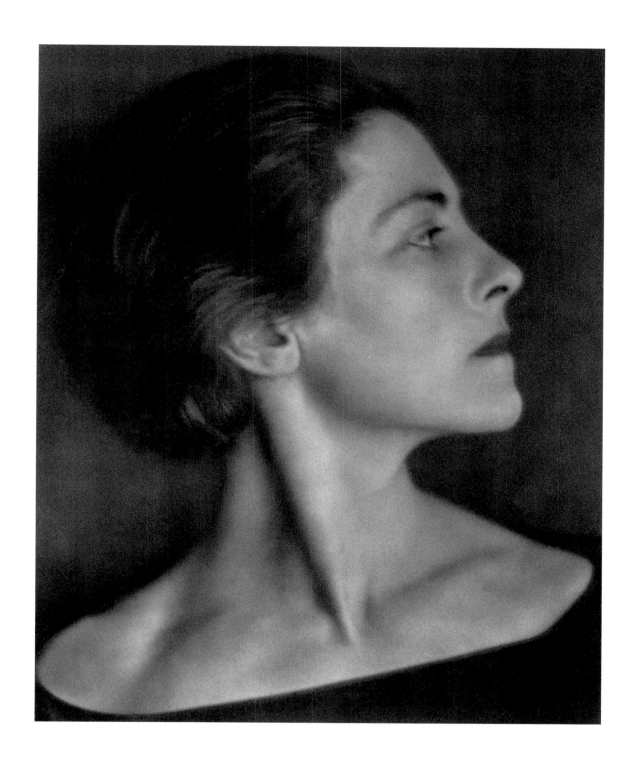

Lois Kellogg, 1923

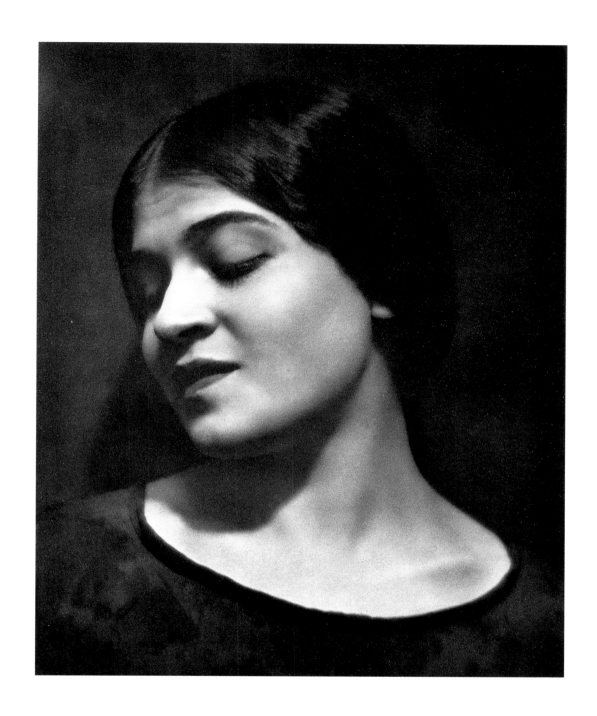

Tina Reciting, 1924

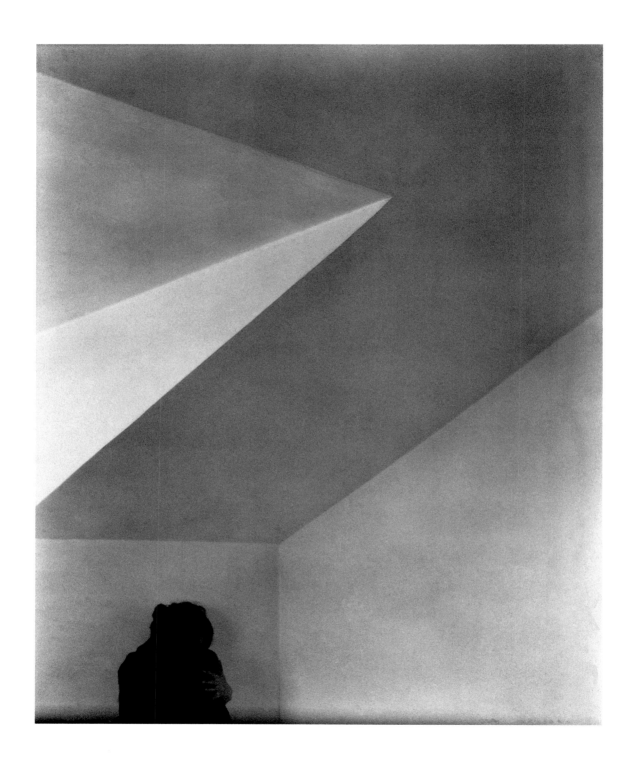

The Ascent of Attic Angles, circa 1921

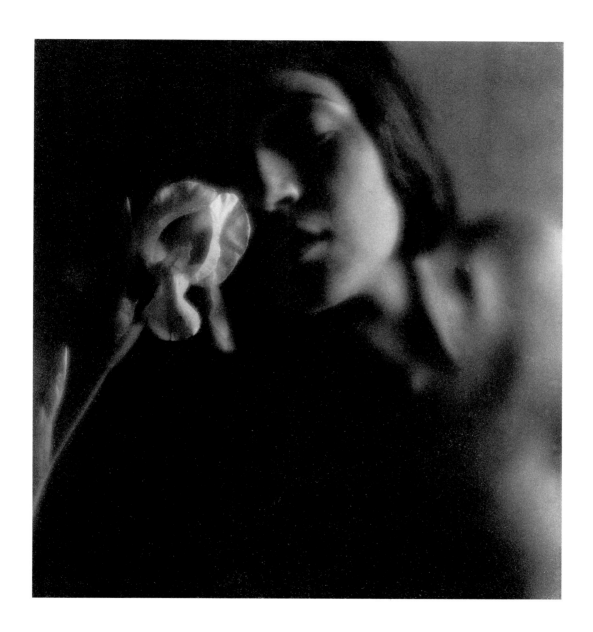

The White Iris, Tina Modotti, 1921

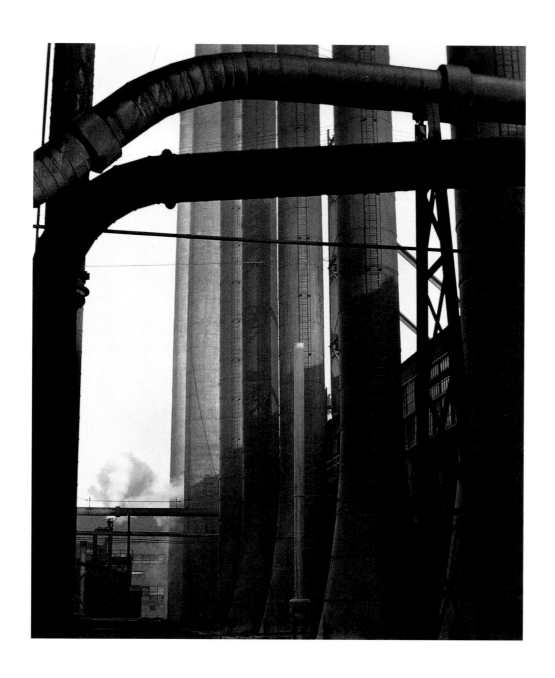

Pipes and Stacks (Armco Steel), Armco, Middletown, Ohio, 1922

Whale Vertebrae, Point Lobos, 1934

Pulquería Mural (Matador and Arena), 1926

95

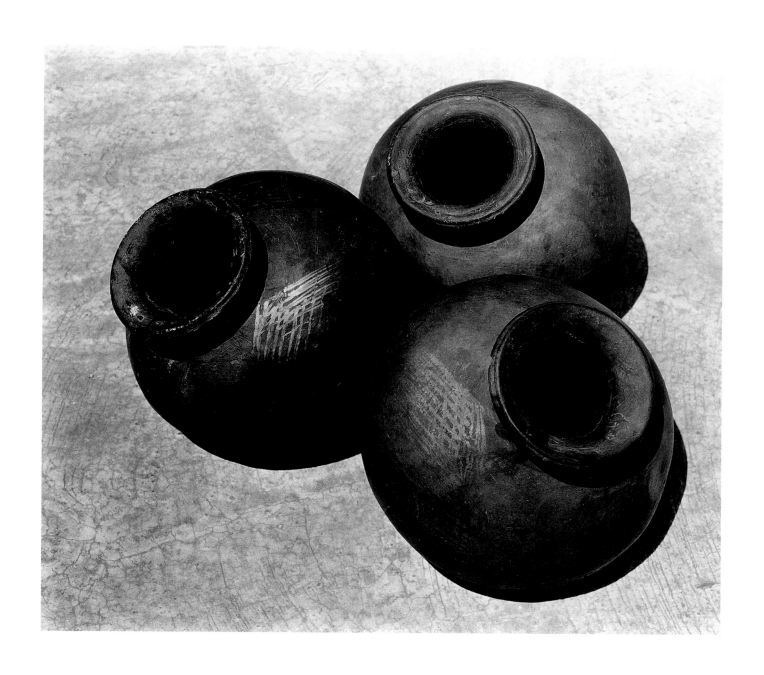

Tres Ollas (Oaxaca Pots), 1926

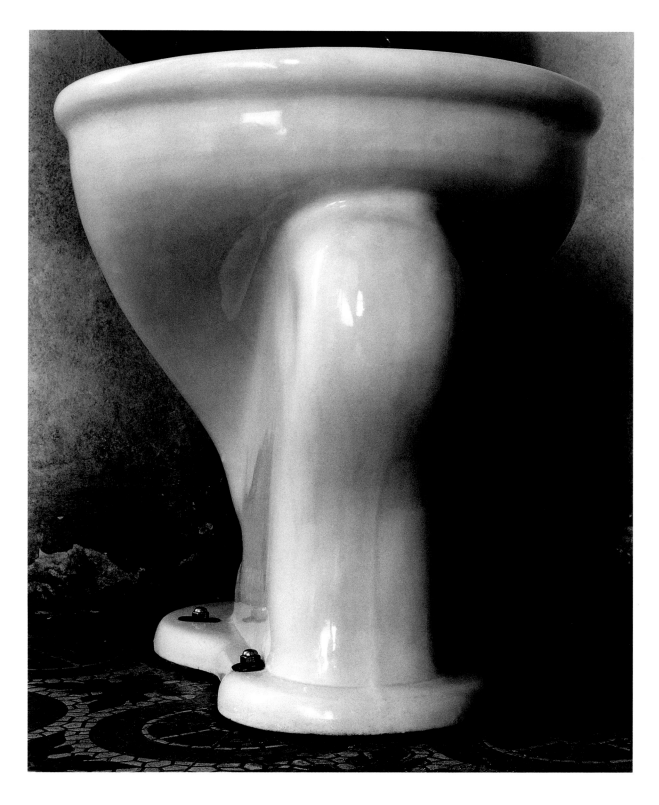

Excusado, Mexico, 1925

Cypress Root and Stone Crop, Point Lobos, 1930

Oak, Monterey County, 1929

Chambered Nautilus, 1927

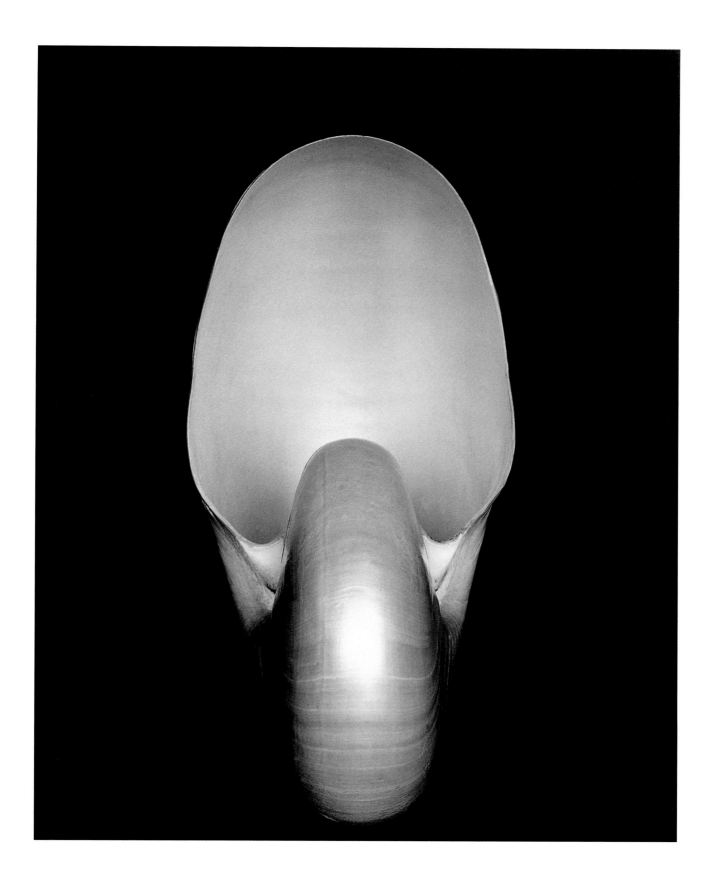

103

Eroded Rock No. 51, 1930

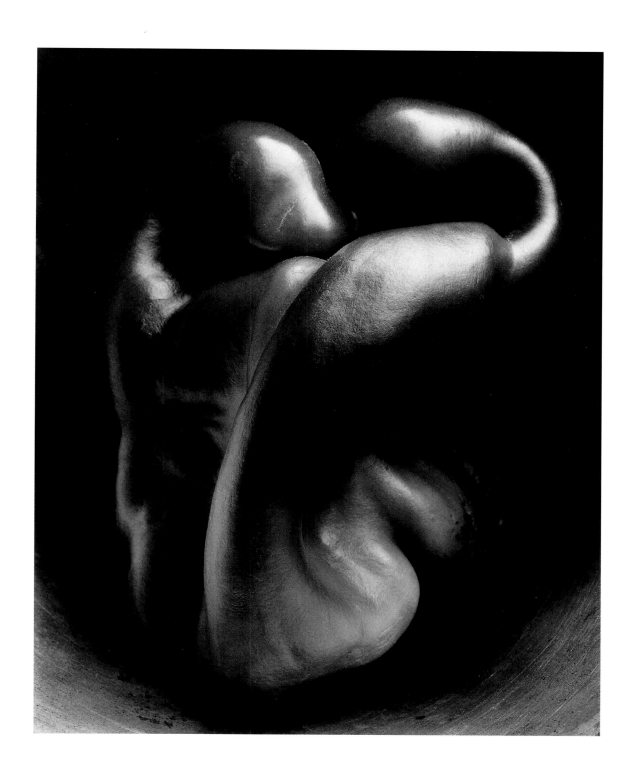

Pepper No. 30, 1930

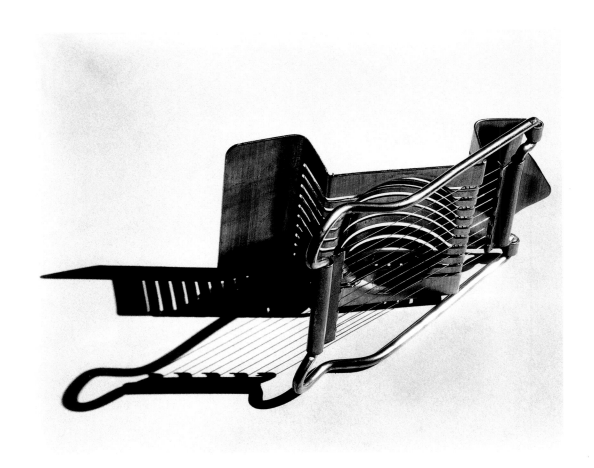

Egg Slicer, 1930

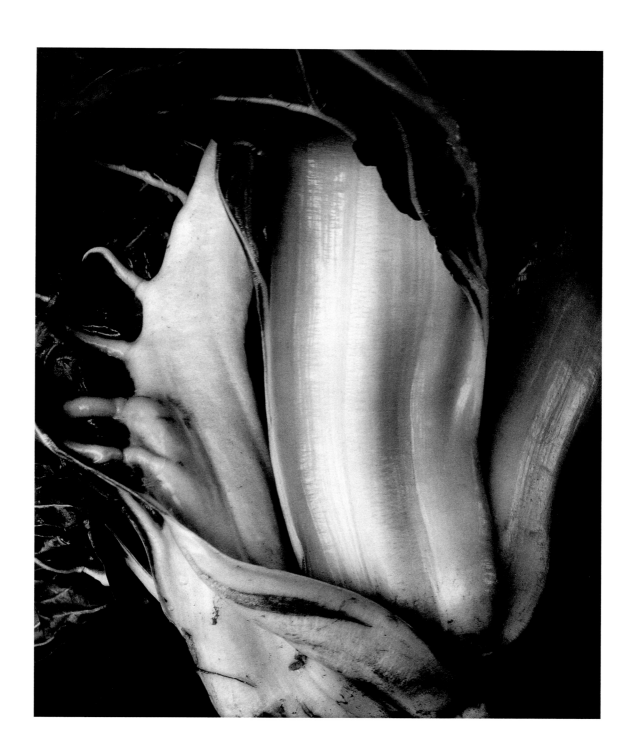

Chinese Cabbage, 1931

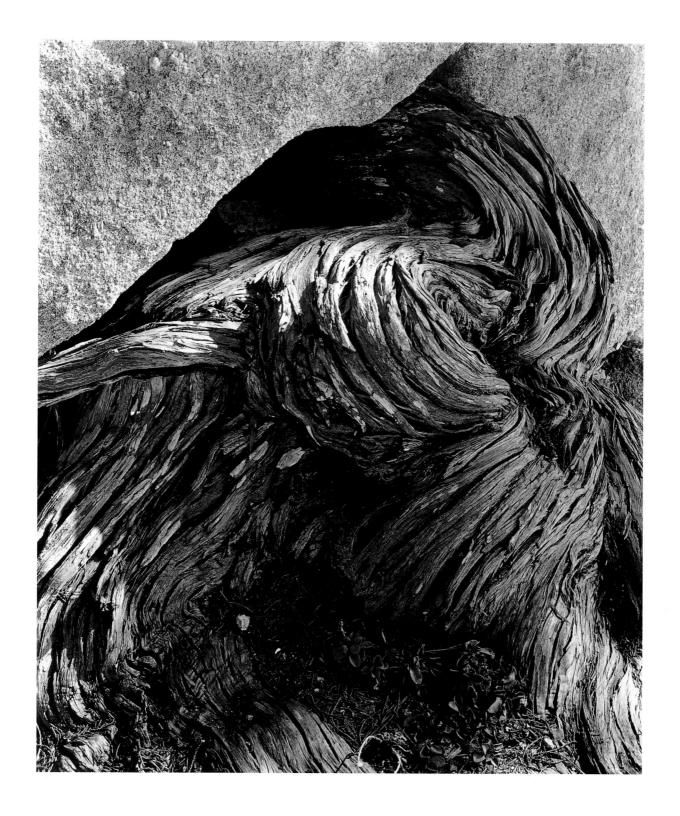

Cypress Root, Seventeen Mile Drive, 1929

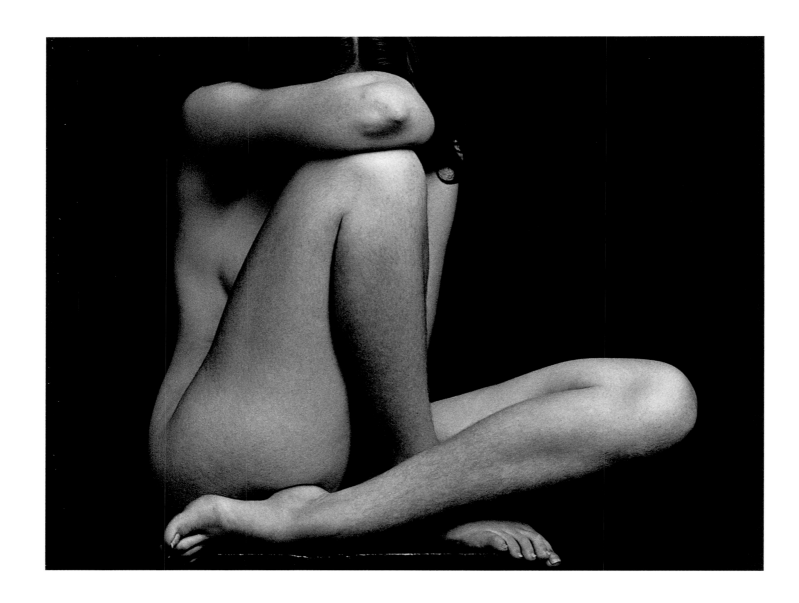

Charis, 1934

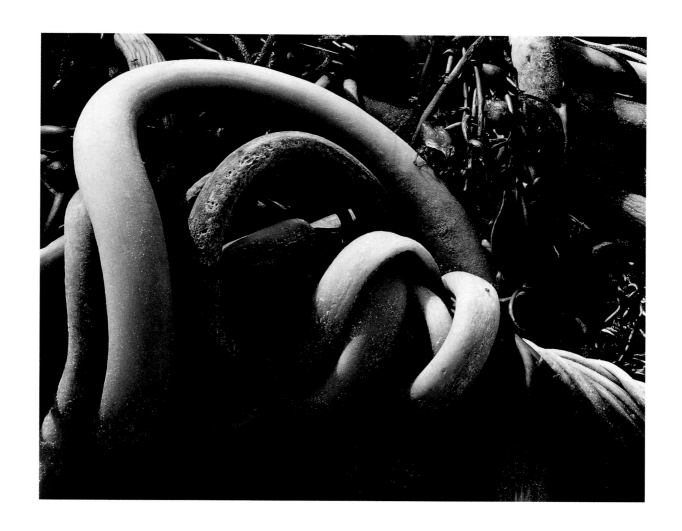

Kelp, 1930

Pelican's Wing, 1931

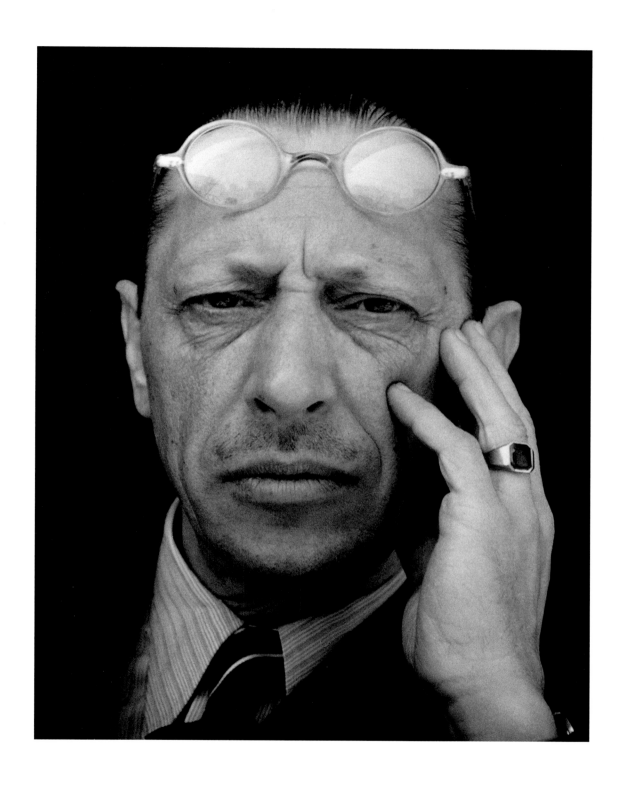

Igor Strawinsky, 1935

113

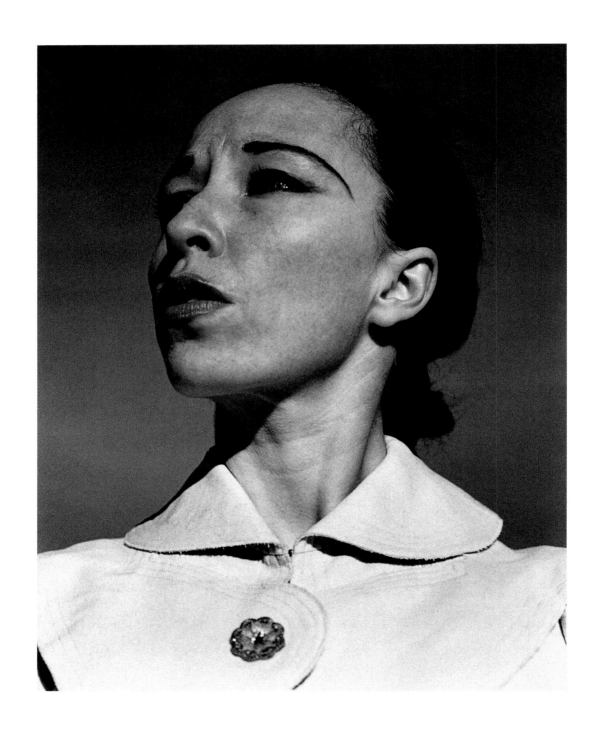

Carmelita Maracci, 1937

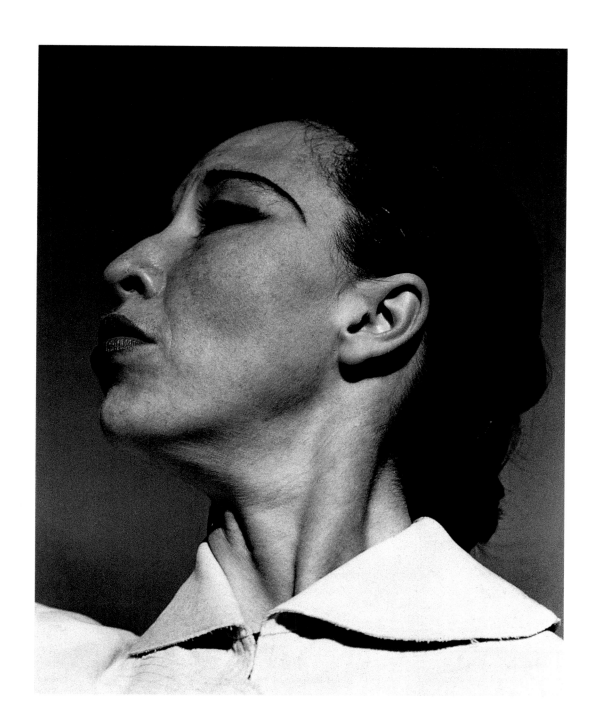

Carmelita Maracci, 1937

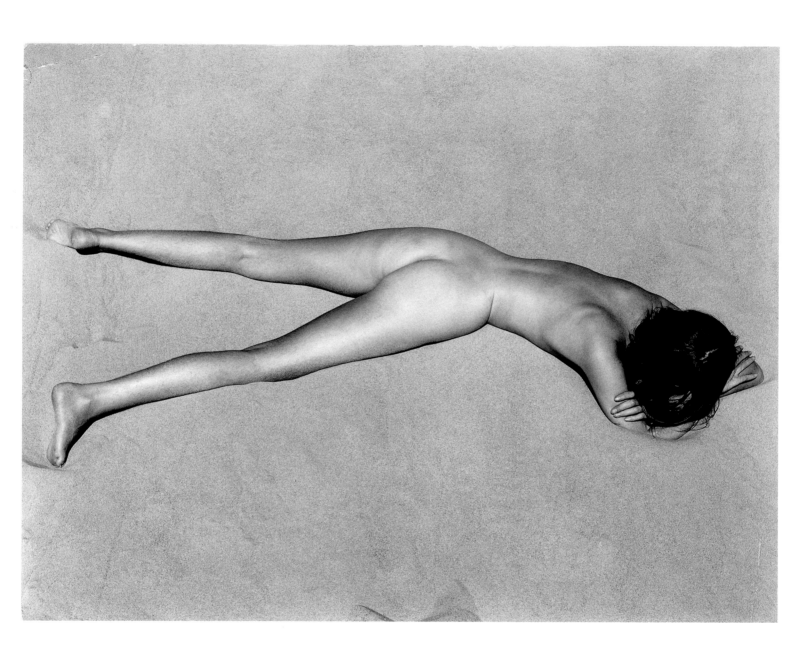

Nude on sand, Oceano, 1936

117

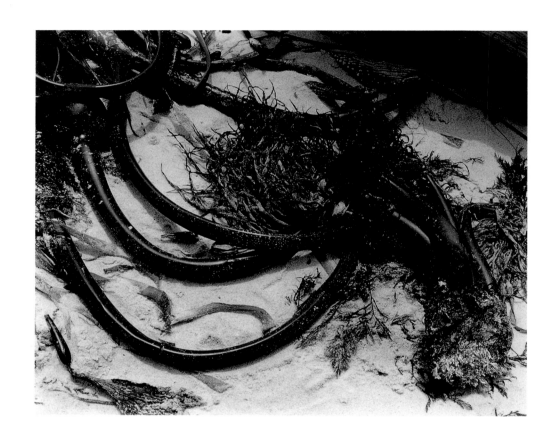

Kelp (with sea palm), 1931

Zabriskie Point, Death Valley, 1938

Dunes, Oceano (White Dune), 1936

Dunes, Oceano (Black Dune), 1936

121

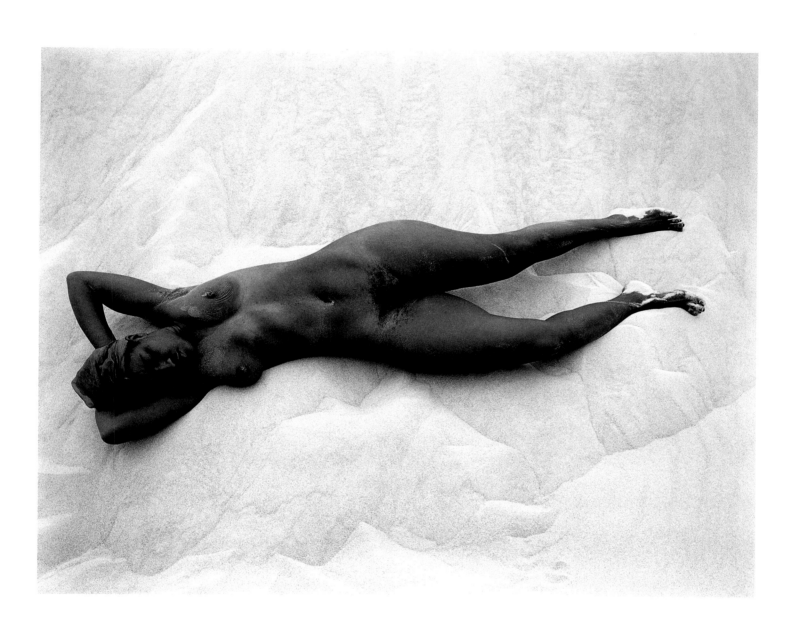

Black Nude on Sand, Oceano, 1939

123

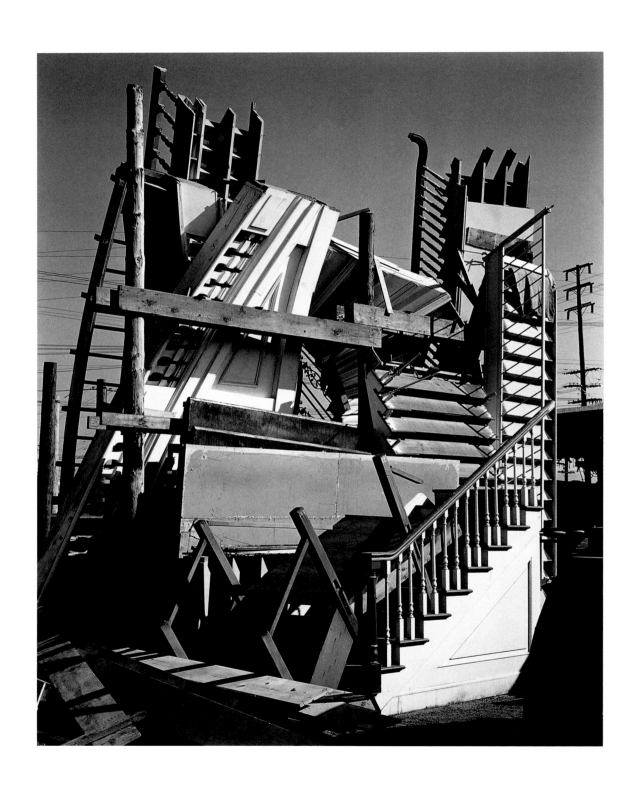

M.G.M. Storage Lot (Stairs), Hollywood 1939

124

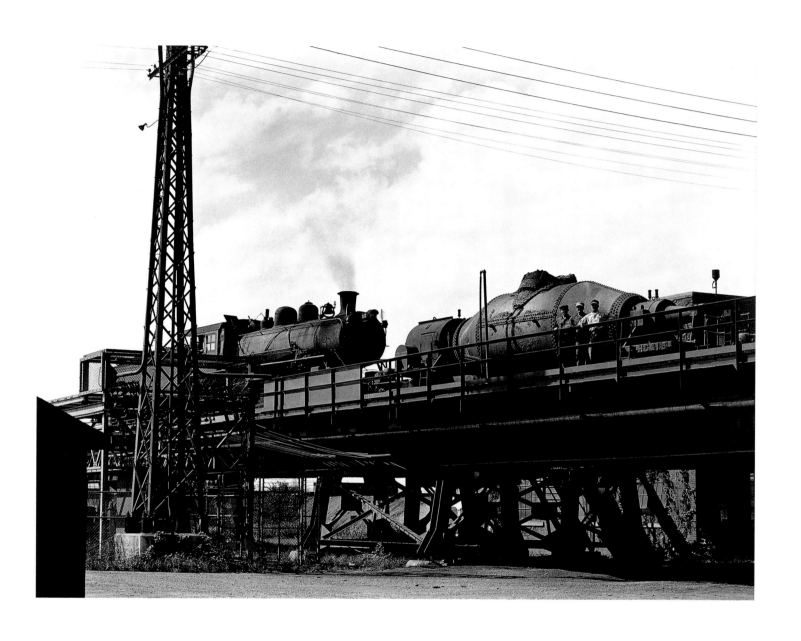

Untitled, 1941

125

Comics, Elliot Point, 1944

"La femme est l'étre qui projette la plus grande ombre ou la plus grande lumière dans nos réves." Charles Baudelaire

Helmut Newton

Woman as Will and Idea

Beautiful, self-confident, strong and independent

by Michael Stoeber

Woman is the focus of Helmut Newton's work. Woman is the continent the artist clearly never tires of exploring. But his expedition into this *terra incognita* is concerned less with discovery than with invention and reinvention. Newton is neither a cartographer nor a documentarist; however realistic his nudes might seem, he is instead a choreographer and a director. Whether he is commissioned to take photographs, or he commissions himself (as in the series *White Women*, *Big Nudes* or *Sleepless Nights*), he devises scenarios, conducts and arranges his models. With each *mise en scène* he opens a new chapter of a continuous story relating his fantasies and phantasms about women. The role played by the woman in this never-ending account is ambivalent. On the one hand, Newton transforms her into an externally determined and malleable object of a specifically male semantics of viewing and yearning, while on the other hand, he places her as a self-determining, dominating subject in the changing fictional roles, poses and charades of an erotic universe.

Helmut Newton has always enjoyed undermining stereotyped preconceptions of his photography. Fired by the ambition to, as he says, "beat the system" at its own game, he has always attempted to extend the range of expressive and design possibilities offered by commission work to explore his own aims and ideas.[1] This genuine

artistic impulse has made Newton a borderline figure, circumventing the categories which separate commercial from artistic photography. As a fashion photographer in the sixties and seventies he took his models off the catwalk and made them the subjects of dramatic narratives. Certainly, the mannequin seen fleeing from an aeroplane in a photo series for British *Vogue* in 1967 never for a second forgets to flaunt the furs she is wearing, the primary reason why she (and Newton) were hired. Yet at the same time, she comes across as a female version of Cary Grant in Hitchcock's film *North-by-Northwest* when he leaps to safety out of the path of a pursuing crop-duster. The threatening atmosphere exuded by the images, the almost archetypal confrontation between man and machine, goes far beyond the requirements of a commercial fashion shoot. That such innovative zeal would soon lead Newton to spark off an entirely new genre of fashion shooting is certainly worth a passing note.

Another of Newton's now famous fashion shots is a picture of a young woman and man he did for American *Vogue* in 1975. Clad in a light summer dress, the woman is sitting on a white sofa watching a bare-chested man in white trousers pass by. Cut off by the picture's top edge, his head is out of sight. This reduces him to the symbol of a body, an otherwise familiar sight in advertising where women are concerned. What makes the picture funny is the manifest switch in gender roles. This impression is emphasised by the woman's pose. She sits there like a man with her legs spread wide; one arm is resolutely jammed onto her hip, the other rests slightly inflected along the top edge of the sofa as if wishing to vaunt her flexing muscles. Her hand is indolently fingering her hair. The woman's probing eyes confidently scan the appearance of the good-looking male. A discreet appreciative smile plays on her lips, the equivalent of the wolf-whistle we associate with a certain type of man when an attractive woman passes by.

As is often the case with Newton, the picture is highly symmetrical, working with reflections and contrasts and exploiting the play of light and dark. The woman is seated and the man is standing, the usual balance of power has been reversed. The woman is fully dressed, the man is half-naked; she is the face, he the body; she is the subject, he the object; she is the central figure, he a peripheral one. Far from being simply a photograph featuring a pretty, light and breezy summer dress and elegant, well-tailored, white trousers, this picture turns into an ironic icon and a critical commentary on clichéd gender roles. Looking at such works, it is hard to grasp the feminist lamentations of purported sexism and discrimination of women in Helmut Newton's photographs.

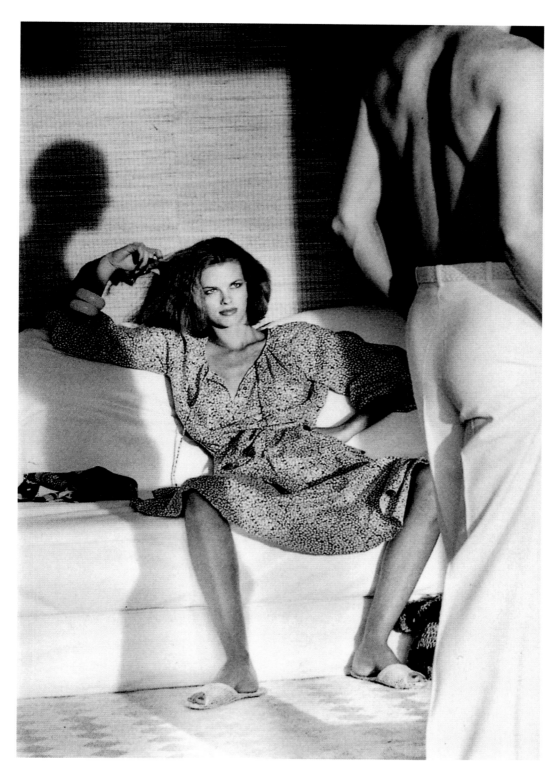

Woman examining man, Saint Tropez 1975

The same applies to the works which Newton has executed on his own behalf and which are fired by his personal artistic volition. His series of *Big Nudes* shows beautiful, confident women posing naked bar high heels in front of an entirely abstract, white background. Such is the lighting in these pictures that even the shadows play no significant role, whereas in other compositions they often act as a kind of dramatic antagonism. The viewer's gaze focuses entirely on the female nudes, with no other pictorial elements to deflect it. It is striking that while the actresses are the object of the viewer's attention, they never actually let themselves be taken in. They are never possessed by the spectator. In spite of their nakedness — often associated with vulnerability — they appear to be anything but weak. They are not risking their hide, as it were, but are sporting it like a shield, like armour, like a queen's gown. The eyes of these women encounter the eyes of the viewer head-on, seem almost to parry and fend him off in a duel of the gazes. The viewer himself becomes the viewed object.

The women assert their autonomy and switch from being the scene's object to its subject. Their postures evince none of the modesty usually allied with nakedness. Neither ashamed nor shameless, the women cross their arms in front of their chests in a virile pose or raise them victoriously above their heads. They vigorously place their arms akimbo or resolutely cross their hands on their laps. It is no accident that from the repertoire of classical nude poses, Newton chose the standing nude rather than the reclining or seated postures for his *Nudes*. Upright and straight-backed, these women possess masculine qualities. This impression is reinforced by the only item worn: the high-heeled shoe. In the Freudian arsenal of sexual connotations the stiletto has an unequivocally phallic significance.[2]

Even when they are tied up, these women still appear to be in charge. The *Tied-up Torso* (Ramatuelle, 1980) does not come across as a helpless victim; with her arm raised and bent, she flexes her muscles as if she were Superman and Tarzan all in one. Not for a moment need we worry about her, quite unlike the bound women photographed by the Japanese artist Araki.[3] In their state of passive capitulation, Araki's women are far closer to being obscure objects of erotic desire than are Newton's. Desire rebounds from Newton's women. They are badly suited for the stimulation of erotic subjugation fantasies. Their beauty seals itself off from the viewer. Even in the series the photographer shot for *Playboy* or *Lui*, he still managed to subtly subvert the orthodoxy of consumerist availability. The women do not

follow a semantic code of passive submission. Newton might highlight the sexually stimulating parts of the woman's body (breasts, thighs and bottom), but instead of being accessible as objects, they act as tokens of female power. However cultivated Newton's protagonists might appear, they in fact belong to the category of wild, powerful and independent women.[4]

His *Domestic Nudes*—a wonderfully ironic title on closer inspection—are anything but domesticated. As *Playboy* centrefolds they are hardly suited to being "taken" between cooking and cleaning duties before obediently resuming the role of the caring housewife. They couldn't care less about the role of "provider" between the sheets or at the stove. Instead, by assuming poses which are equally mannered, artificial and emphatic, they assert *their* right to sexual "provision." They are not there to gratify male wishes: men are there to wait on them. Hence it is hardly surprising to see a portrait of the photographer himself featured on a page of the *Los Angeles Times* lying crumpled and "disposed of" in the waste-paper basket in *Domestic Nude I* (Hollywood, 1992).

The gesture of artificiality with which Newton imbues the bodies and poses of his actresses is further amplified by the formal elements of decor he appropriates from the history of art and film. Commentators of his work have repeatedly confirmed such analogies and similarities. In his exegesis of the portrait of the photo model *Patti Hansen* (Paris, 1977), Klaus Honnef points out Newton's allusions to the positions of "classical aesthetics." In the portrait Honnef sees a "blasphemous" travesty of the Madonna opening her gown. Indeed, Hansen is shown pulling apart the straps of her suspender belt as if she were opening her gown, thereby inverting a "benign gesture into one of obscenity."[5] But only those who are *au courant* with the history of art will spot the construction, and Newton's admirers are more likely to appreciate his flair for making allusions than to take religious offence.

The transfer of fashion and erotic photography into art can be observed in other works too. *Roselyne on Napoleon's Bed* (Paris, 1975) is lounging like one of Boucher's reclining nudes. But whereas the rosy flesh of the willing, seductively smiling beauty created by the rococo painter seems to be inviting the viewer to join her in an amorous tête-à-tête, Roselyn just smokes her cigarette, utterly absorbed in her own thoughts. Her head is averted from the viewer, giving the impression that she suffices unto herself. In the same vein, Newton's pictures contain a plenitude of other references and allusions to works by Fouquet, Goya and Manet, or to

films by Fritz Lang, Erich von Stroheim or Alfred Hitchcock. Yet regardl ess of the differences in tone and theme in his pictures, the attitude of independence and the self-referential gesture are typical of the Newton woman.

It is impossible to overlook the photographer's obsessive fixation on the powerful woman. This might conceivably have an autobiographical background. Newton was born in Berlin in 1920. The volatile moods of the first German Republic, the "Roaring Twenties" in the German capital, a period of artistic and cultural experimentation, but also one of reappraisal and revised traditional roles — these truly turbulent and eventful times formed the background of his youth. This period must have had a lasting effect upon Newton. In Berlin he took up his profession and artistic career as the pupil and assistant of fashion-, portrait- and nude photographer Yva.

It must indeed have been painful for Newton to have been forced to leave Germany in 1938 as a Jew. Everyone who has endured such traumatic circumstances describes the resulting feeling of utter helplessness and a nightmarish loss of reality.[6] For those involved, reality in all its familiar forms seemed to be ruthlessly dissolving. It is likely that his experience of such impotence kindled the desire to recoup power and absolute control over his own life. This may be the source of the precision with which Newton, leaving nothing to chance, arranges and instrumentalises his pictures. In response to the sense of alienation, mistrust and existential doubt engendered by things as they were and are, his impulse is to go further than just controlling the *mise en scène* of so-called reality and to stylise, exaggerate, transpose and ultimately to recreate it: the artist as the master of the artificial.

Subsequently, the motif of the controlled and controlling female in his pictures — the "cool woman" to use Newton's words — could be seen as a response to the ordeal of having been exiled and psychologically depossessed by Nazi Germany.[7] His pictures are repeatedly concerned with power and impotence. In his game of reversed roles, power is given to the weak and removed from the strong: woman is confidently triumphant. Hardly surprising then that she also displays ambivalent traits. To repel an attack one must adopt some attributes of one's attackers, and the great mother of all myths is never harmless. Sometimes she eats her own offspring. Newton says: "My women will always win,"[8] and with their help he might conceivably be forever trying to compensate for the humiliation he once suffered.

This sense of victory hand in hand with his women must then reach its peak when he prepares the stage for their performance, when the women follow his instructions in front of the camera lens and when he becomes the creator of his creations. This undoubtedly gives him a highly intense feeling of autonomy. Furthermore, this deep-seated insecurity may also explain Newton's lifelong partiality for the company of the rich, the powerful and the beautiful, his predilection for the world of luxury, elegance and wealth. For this elite section of society has the means of erecting formidable buffers against encroachment from the rest of the world.

The ambivalence so characteristic of the woman's role prevails over the *mise en scène*. Moments of anarchy flash through the carefully construed composition. The photographs are grounded in unfathomable terror, sombre shadows, intimations of rape, torture, murder and slaughter. Not even the bulwark surrounding big money and exclusive society can offer protection, as the recent murder of Versace once again proved.

Paradoxically, it is precisely the evocation of the spectre of terror that also affords the possibility of its repudiation. The pledge of art always culminates in the banishment of evil spirits. In the series *American Playmates* (Los Angeles, 1997), the protagonists are once more completely naked but for their stiletto shoes. However, they make their appearance not in an empty, virtually abstract room, but in some petit bourgeois and typically American part of suburbia. In their state of attire they harmonise with the surroundings like nuns in a brothel. And yet this is also why they arouse repressed obsessions, cravings and nightmare visions not dissimilar to the scenario in David Lynch's film *Blue Velvet*.

Contours and contrasts are starkly juxtaposed, the images' definition could hardly be sharper — nonetheless everything remains inconclusive. In spite of total clarity, nothing is clear. The actresses assume a variety of poses. With one hand on her hips and a cigarette in the other, one woman simply stands there looking at one and the same time provocative and dismissive. Another is lying on the road. Is she the victim of some mysterious act of violence or is this a leisurely invitation to make love to her à la *Why don't we do it in the road?* And yet another is hanging onto a beam with outstretched arms like a gymnast, but also like an iconographic reference to the ancient myth of the flayed Marsyas. And then another woman with her arm extended as if someone were intending to denounce or arrest her. Her gesture calls to mind Diana, the goddess of hunting, or one of the heralds of communism depicted by Vera Mukhina in the 1937 World Exhibition in Paris.

Again, the title of the series *American Playmates* can only be taken as ironic. It is not we who are playing with these women, but they who are playing with us and our fantasies. The ambivalence and contrivedly synthetic nature of the setting is heightened by our realisation that this small-town milieu is in fact a simulation, nothing more than a large-scale studio photograph, a kind of backdrop, and that these scenes are performed on a studio stage or floor, similar to the way Hitchcock shot certain film sequences against a studio back-projection. Each documentary reflex inherent in black-and-white photography is cancelled by the exaggeratedly dramatic light effects, and also because the pictures are twinned with hyper-artificially coloured counterparts. We are again reminded of Lynch's *Blue Velvet*. Things are not what they seem, but what they exactly represent we cannot know for sure. The highly synthetic realism of these photographs is emblematically inscribed with a sense of deep-seated insecurity.

The enigmatic exchanges between reality and artificiality come to a head in those photographs which depict dolls as protagonists. The perilous handstand performed by a woman high up over the railway tracks could hardly be more accomplished. The figure's entire physique has the aura of harmonious organisation. During this daredevil display the artiste even avoids her skirt riding undaintily up her thighs. It only becomes evident that we are in fact looking at a doll when we inspect the utterly improbable posture of the body performing its handstand. The artificiality is compounded by the photographic composition, an overall arrangement of verticals and horizontals. The railway lines flowing through the picture and the landscape are structured like stop signs by the upright figure in the foreground and the towering church in the background.

The mannequin in *The 13:50 from Milan* (Bordighera, 1996) also makes a deceptive impression. The almost lustful ardency of the figure jars with the hands strangling it. No instinctive resistance, no spasm under the asphyxiating grip—everything takes place with Apollonian grace.[9] Motionless as a statue, the figure's pristine, petrified and immobile pose stands in radical contrast to the train thundering past. In an act of high artificiality this unprecedented drama of violence and aggression is momentarily snatched from life and transferred into art. Both aesthetic and manipulable, the dummy's synthetic body is an ideal partner for the artist's theatrical imagination. Offering no contradiction, the doll forms and deforms itself, utterly acquiescent to its master's most outrageous wishes.

136

Hans Bellmer, for whom the mannequin became a figure of projection for an entirely distinct anatomy of love, complained that the dummy "managed to remain agonisingly reserved despite its limitless tractability."[10] It is probably this ambivalence between availability and withdrawal which also makes the doll so attractive to Helmut Newton.

The entry of the (synthetic) mannequin into Newton's work was heralded in a series of photographs showing models and (human) mannequins trussed up in leather halters and cuirasses which clasp neck and torso and partially immobilise them. Particularly famous are the portraits of Paloma Picasso and Suzy Dyson, who in their orthopaedic outfits resemble artificial dummies. Newton went one step further in the series *In Dummyland*, in which he assembled inanimate and human mannequins, arranging them in such a way as to make it hard for the viewer to tell the difference. At this juncture the artificiality of reality reaches its peak. One gets the feeling that Newton is orienting his compositions towards a notion of ideal beauty which in his own eyes is embodied in its purest form by the image of the synthetic woman. She appears to be purged of all flawed, human traits.

In *The 2 Violettas in Bed* (1981, Paris) a model is lying on the bed beside a perfect facsimile of herself, like identical twins. Except that her replica is more perfect, the skin still smoother, its complexion even closer to alabaster, irreproachable and wrinkle-free, the serene expression on its face forever untarnished. One is reminded of Heinrich von Kleist's reflections in *Über das Marionettentheater* (On the Marionette Theatre) which examines the threat to "charm" and "grace" posed by human self-consciousness.[11] Whereas Kleist represents the puppet as a mythical formula for a life unsullied by reflection prior to the Fall of Man, Newton's dummy seems to embody a figure in the wake of the Fall which, with its self-referential and immobile character, not only displays grace in its purest form, but also (and paradoxically) autonomy.

Besides the woman as the foremost object of his theatrical desire, besides the portayal of the rich, the powerful and the beautiful, a further recurring motif in the photographer's pictorial work is the self-portrait. An early picture from 1936 shows Helmut Newton from the waist up in semi-profile wearing a white lab coat as he is fixing a camera onto a tripod in Yva's studio. Bearing an expression of earnest concentration, the gaze of the young photographic assistant is pointed at something outside the picture. In a second picture taken in the same year we see the sixteen-

year-old on the beach of Halensee lake in Berlin, carrying off the feat of putting his arms around three girls all at once. Both images seem to suggest the key thematic motifs of his subsequent life.

Forty years on, the *Self-portrait with Model* (Paris, 1973) combines both motifs in one image. It shows Newton recumbent on a Parisian hotel bed with a woman lying on top of him. The scene is doubled by a mirror and captured by a camera with automatic shutter release. In another self-portrait (Los Angeles, 1987) Newton is again caught up in one of his own scenarios. A model is lounging on a bed in a carefully studied pose of oblivious devotion or exhausted negligence. A carelessness which is mirrored in the untidy room. Her slip has slid up her body exposing — almost at the picture's centre — her pudenda. In the foreground Newton is sitting in an armchair with outstretched legs as if he were having a rest. Only the extended hand holding the shutter release divulges the concentrated work invested in this scene. He is gazing into the picture's interior along the same axis as the viewer's gaze.

Yet another self-portrait, *Me and Courbet* (Paris, 1996), shows him in the Musée d'Orsay in the company of the painter's famous canvas *L'origine du monde*, which with its bold diagonals and foreshortened perspective also focuses the viewer's attention on the female genitalia with drastic clarity — far more drastically and far more clearly than Newton does in his 1987 self-portrait. The photographer's head can be seen underneath the painting. Cut off by the picture's bottom edge, all that essentially remains of his face are his eyes. Since Georges Bataille, the analogy between eye and vulva has become something of a platitude.[12] Far more surprising is the impression one has that in this instance Newton is actually trying to distract the viewer's gaze with his own eyes in an endeavour to protect the overly obvious and utterly exposed genitalia.

In the famous series of voyeurism studies, Newton (as arranger and choreographer) is also inserted partially or entirely inside the picture. These pieces have often been interpreted as an expression of the interdependence of voyeurism (made more than obvious by the title) and exhibitionism. Newton's presence in these shots — even if only marginally, where an arm or a leg first has to be spotted by the viewer — is reminiscent of an old iconographic tradition which extends from the cave painter's hand imprint, through the signatures of medieval architects, up to Hitchcock's occasional appearances in his films. They all included themselves in their pictures as the authors of their works. In Newton's case one often has the

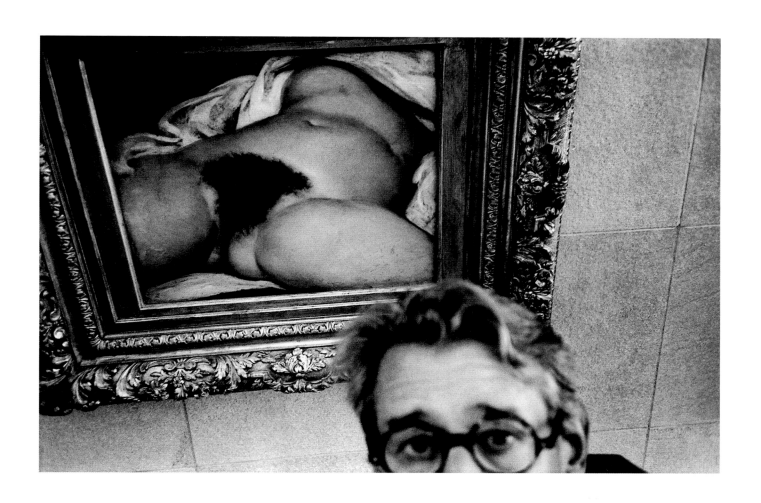

Me and Courbet, Musée d'Orsay, Paris 1996

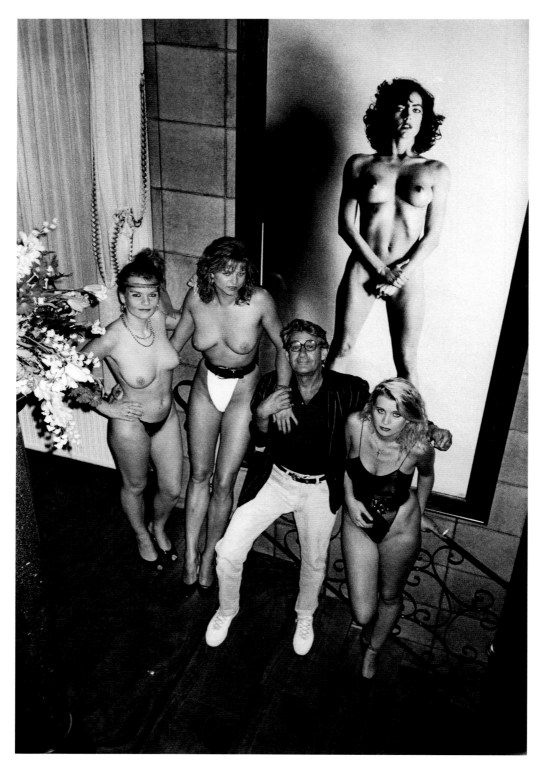

In a brothel in Frankfurt, 1988

140

impression that as the creator, he wishes to imbibe strength from his creations and satiate himself at their expense, an act which in magical and analytical terms is much easier to perform if he first of all furnishes their fictional personae with a maximum of strength.

In a work from 1988 we see Helmut Newton inside a Frankfurt brothel. He is surrounded by three semi-naked women. The photograph comes across as a self-ironic reprise of the Halensee motif of fifty years before: the man who loves women. But a travesty can also be identified: Newton as the aged figure of Paris constrained to decide which candidate possesses the greatest beauty. Ultimately there is a contra-diction between enacted beauty and deficient reality. Photographed from above like a shining star, an ideal nude from the *Big Nudes* — beautiful, self-confident, strong and independent — thematically towers over this scene.

Then there are the various self-portraits which show Newton alone in front of a mirror. Whether their manner is contrived or matter-of-fact (such as the docu-ments from the clinic), these scenes make no attempt to depict Newton as a com-pelling ego. This applies to his self-portrait in an ingenious double reflection inside his hotel room, naked up to his thighs and wearing long black stockings (Biarritz, 1993), as it does to the equally ingenious photographs of a picture within a picture, a room within a room in the Hotel due torri in Verona he shot in 1976, where he him-self virtually disappears into the background of the photograph. In his clinic pictures from New York (1973) and Monte Carlo (1997) Newton portrays himself with un-sparing frankness in moments of great frailty. With electrodes plastered all over his body, his submissive dependence on the clinical apparatus makes him a pitiful sight indeed. In another photograph taken in 1997 in a hospital in the French town of Cagnes-sur-Mer, electric plugs and switches are wrapped around his head like a mandorla or crown of thorns, making him look like a latter-day Man of Sorrows.

In the self-portrait the picture's subject and object merge into one. The artist posing as his own model does, of course, belong to a long tradition. However, in this century Jacques Lacan has taught us the importance of the mirror stage for the for-mation of the self-identity during human development.[13] The frequency with which self-reflective self-portraits occur — the portrait of a portrait of a portrait — strongly suggests that Newton regularly uses such pictures to reassure himself of his own existence.

In their absence of idealisation, the self-portraits also offer the necessary corrective and complement to a truly ambivalent understanding of physicality. Em-

bracing the languages of desire and pain, the images of youth and beauty, of infirmity and ephemerality, Eros and Thanatos, art and nature, Newton's work ultimately achieves a vision which encompasses the whole of human existence. Like a modern, shining *memento mori*, the picture which best and most revealingly condenses the dialectic of his visual imagination, was shot in 1979. It is an x-ray of a woman. Tied around her transient neck is a sumptuous string of diamonds.

Translation Matthew Partridge

Footnotes:

1 Klaus Honnef, "'Ich bin ein guter Beobachter von Leuten', Helmut Newton und seine Welt" in Helmut Newton, *Portraits* (Munich, 1987), pp. 16ff.

2 Friedrich W. Doucet, *Lexikon der Sexualsymbole* (Munich, 1971).

3 Nobuyoshi Araki, *Tokyo Nouvelle* (catalogue Kunstmuseum Wolfsburg, 1996).

4 Hans Peter Duerr, *Traumzeit — Über die Grenze zwischen Wildnis und Zivilisation* (Frankfurt am Main, 1985).

5 Cf. Klaus Honnef, op. cit., p. 3.

6 Vilém Flusser, *Bodenlos — Eine philosophische Autobiographie* (Düsseldorf, 1992), pp. 23ff.

7 Karl Lagerfeld, "Nordfleisch" in Helmut Newton, *Big Nudes* (Munich, 1990), p. 9.

8 Noemi Smolik, "Akte des Anderen" in Helmut Newton, *Aus dem photographischen Werk* (Munich 1993), p. 18.

9 Urs Stahel, "Teilhaben ohne Folgen, Regeln und Spielformen des Newton'schen Voyeurismus" in Helmut Newton, *Aus dem photographischen Werk* (Munich, 1993), pp. 27–28.

10 Hans Bellmer, *Die Puppe* (Frankfurt am Main, 1983), p. 12.

11 Heinrich von Kleist, *Über das Marionettentheater* (Frankfurt am Main, 1982).

12 Georges Bataille, *Der heilige Eros* (Frankfurt am Main, 1979).

13 Jacques Lacan, *Schriften*, Vol. 1 (Freiburg, 1980).

Helmut Newton

Self-portrait, Hotel Royal Monceau, Paris 1994

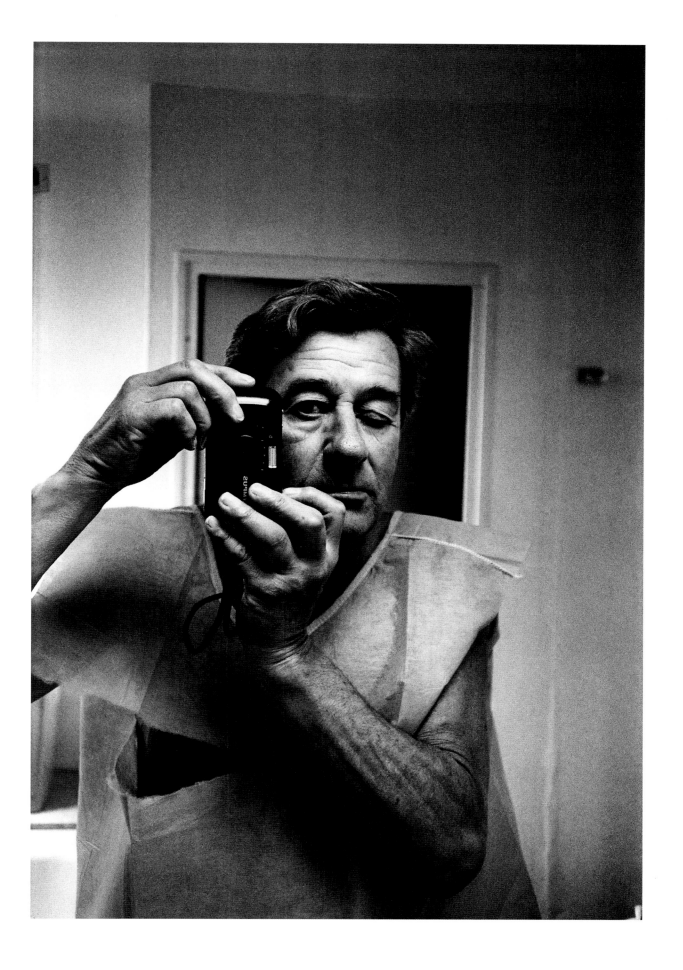

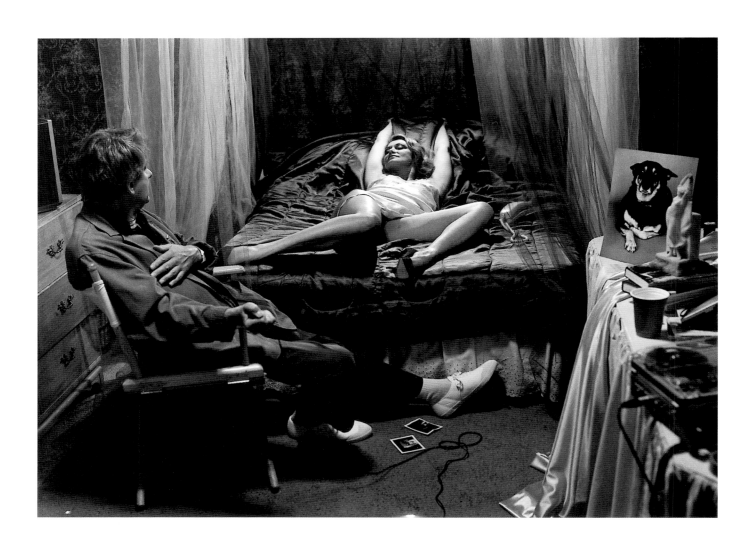

Self-portrait, Valentino Place, Hollywood 1987 | Self-portrait with model, Paris 1973 ▶

146

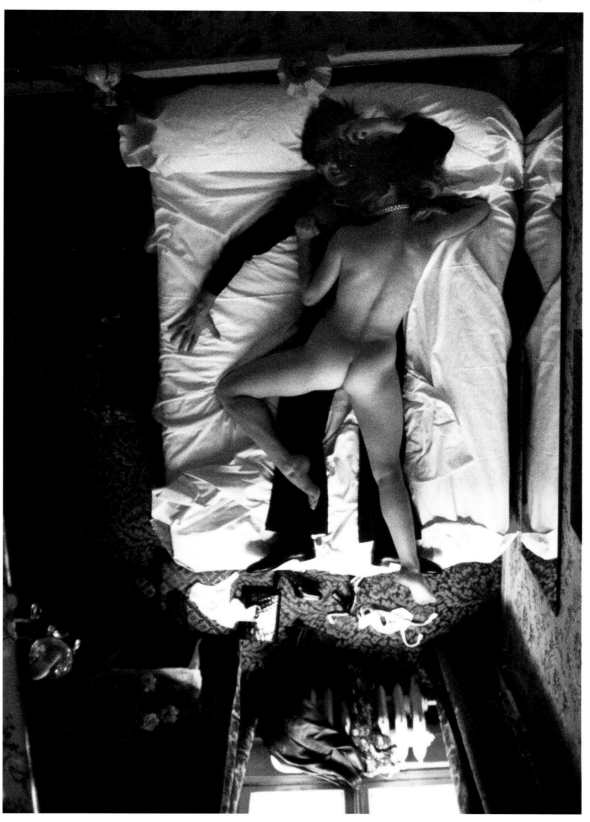

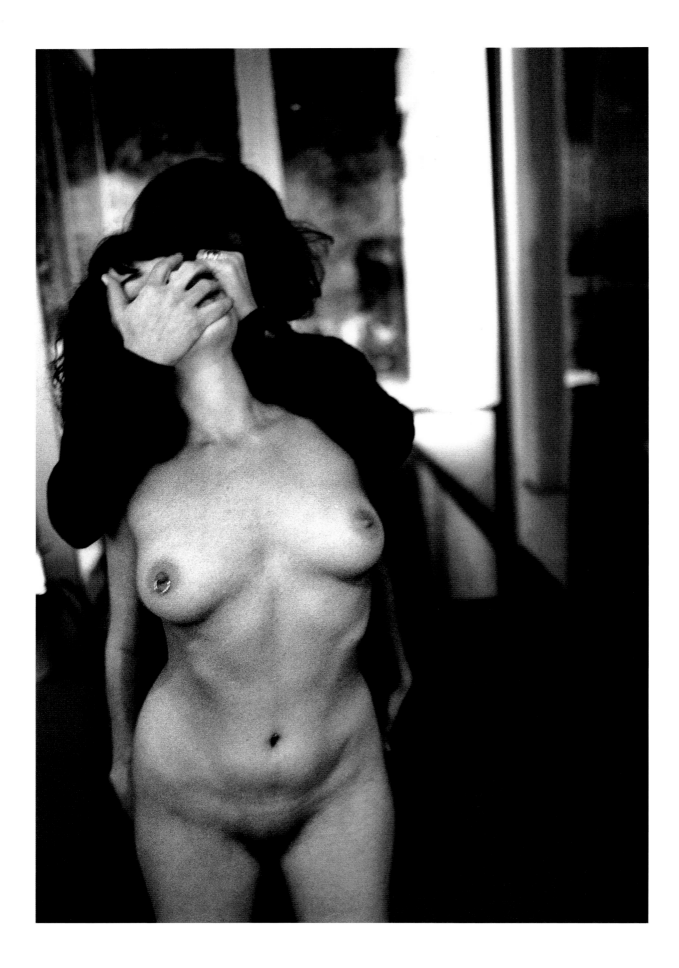

◄ Date Rape, Beverly Hills 1991 | Polaroid paper negative, Paris 1997

149

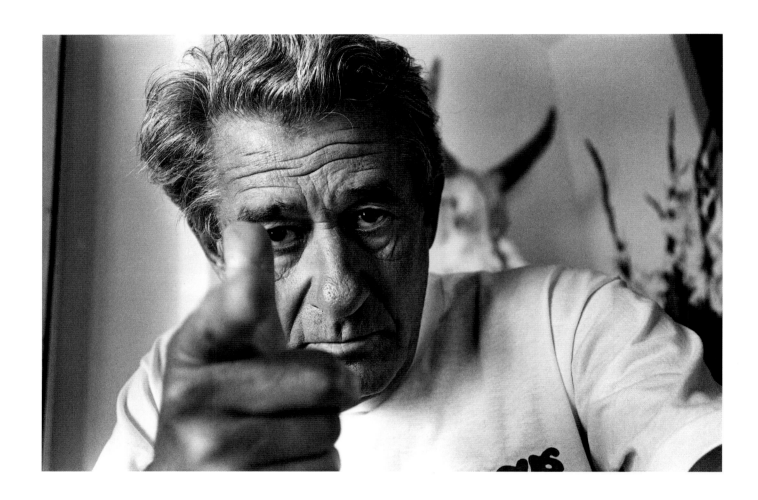

Self-portrait, Monte-Carlo, October 1993 | Clinique St. Jean, Cagnes-sur-Mer, September 1997 ▶

150

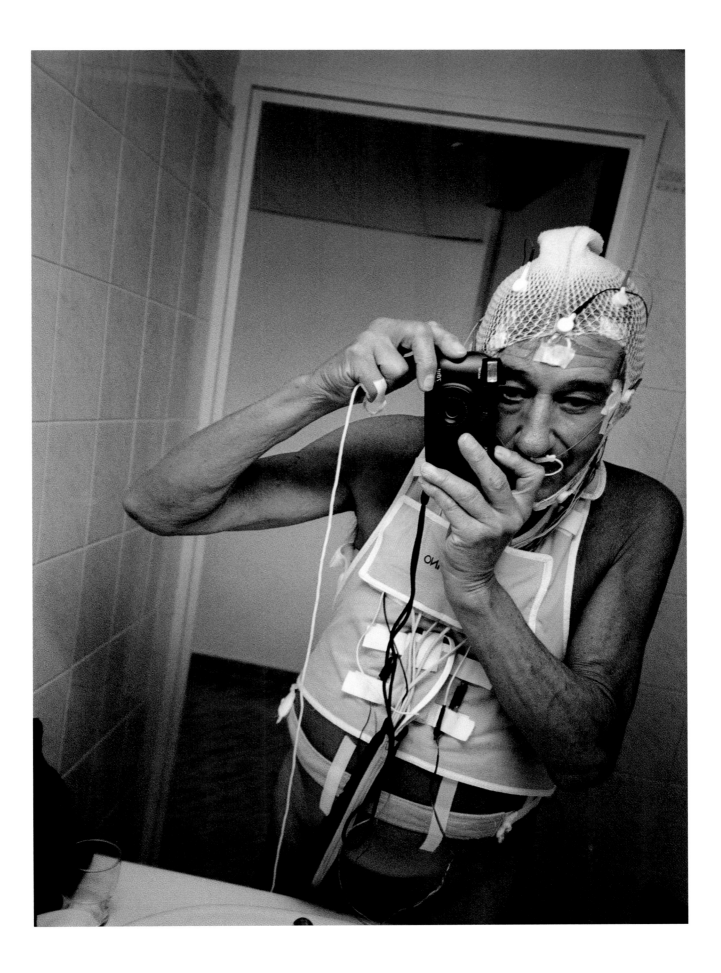

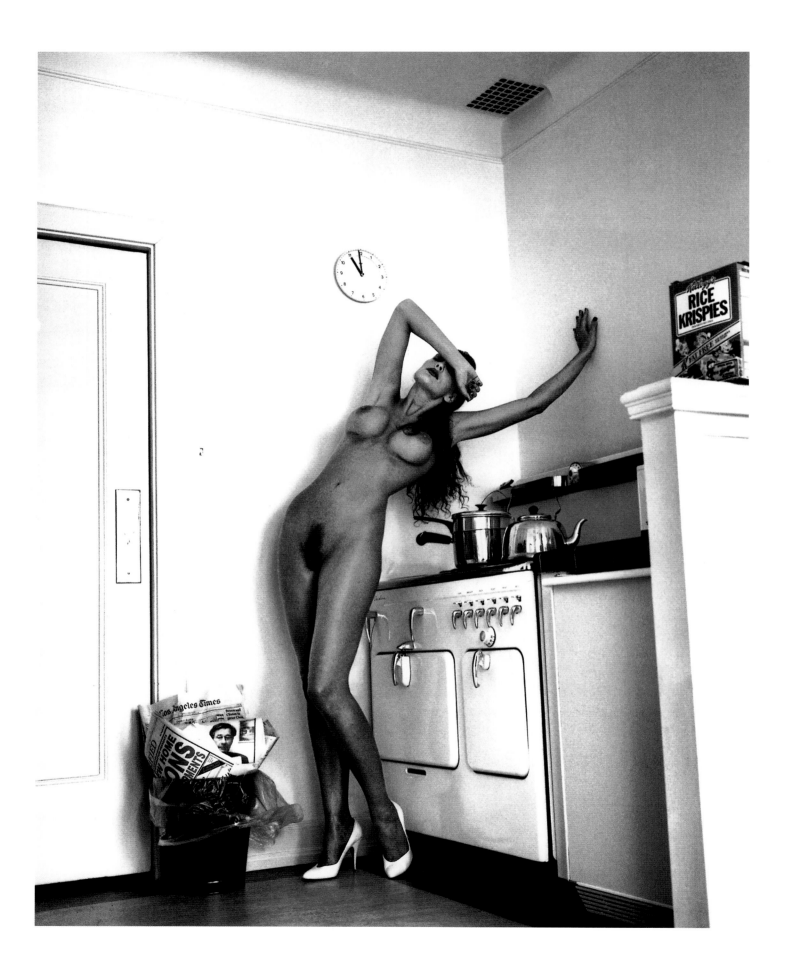

◄ Domestic Nude I – In my kitchen, Chateau Marmont, Hollywood 1992 | Hotel TV Screen, Intercontinental, Berlin 1994

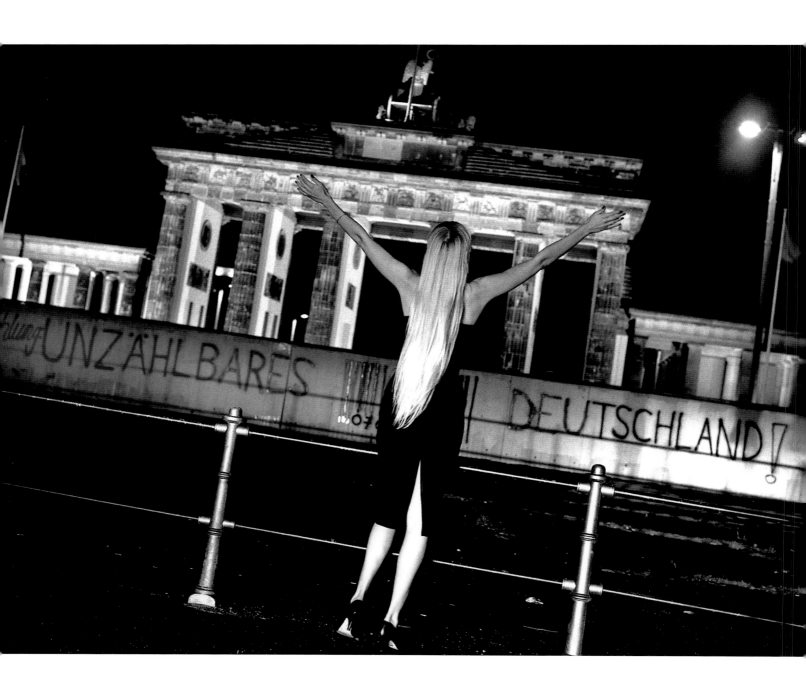

Brandenburg Gate and the Berlin Wall, Berlin 1987

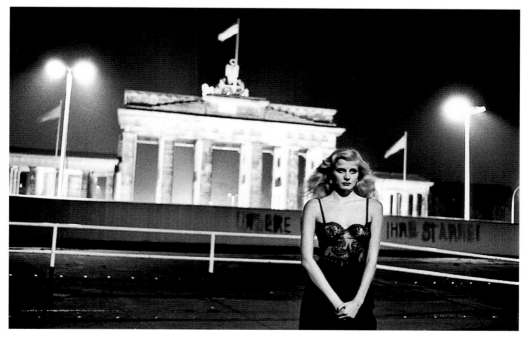

Death corridor, Berlin 1981 | Brandenburg Gate and the Berlin Wall, Berlin 1987

155

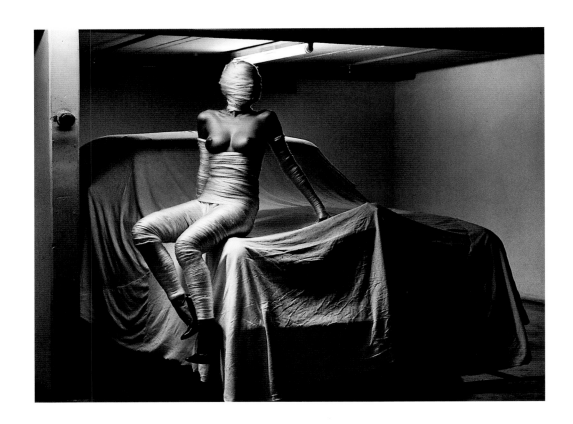

In my garage, Monte-Carlo 1986

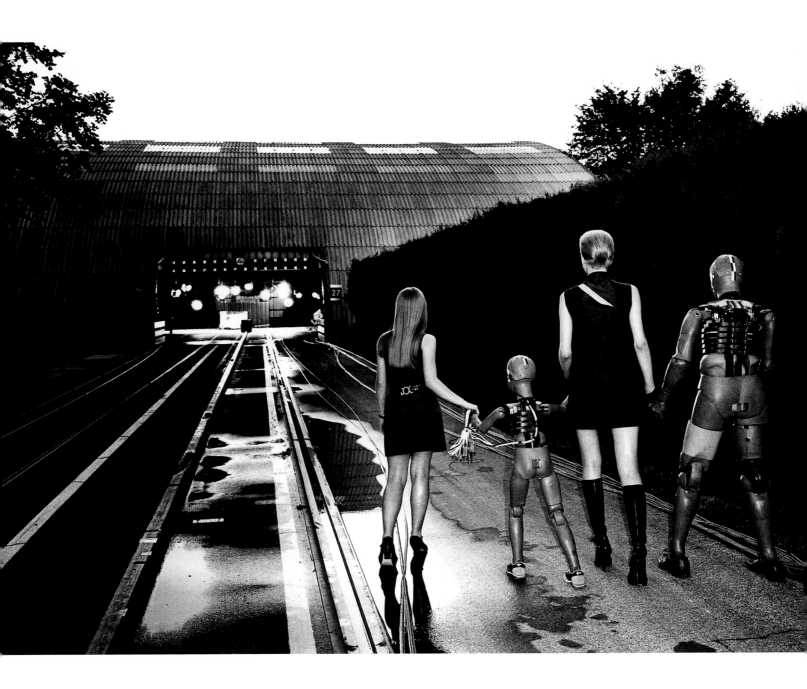

Going Home, France 1997

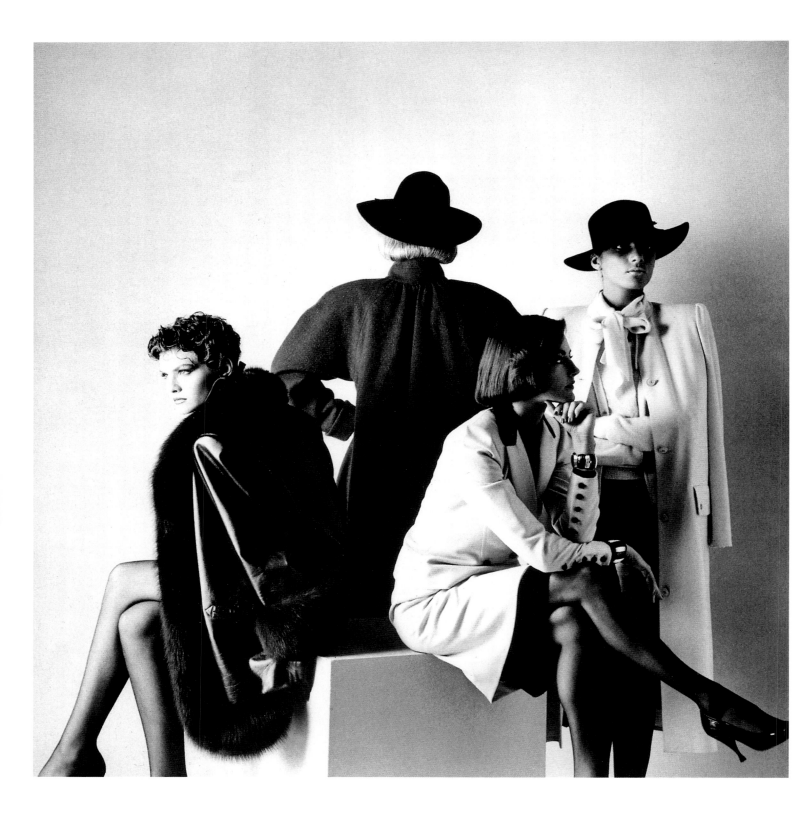

Four Dressed Fashion Models Sitting, Paris 1981

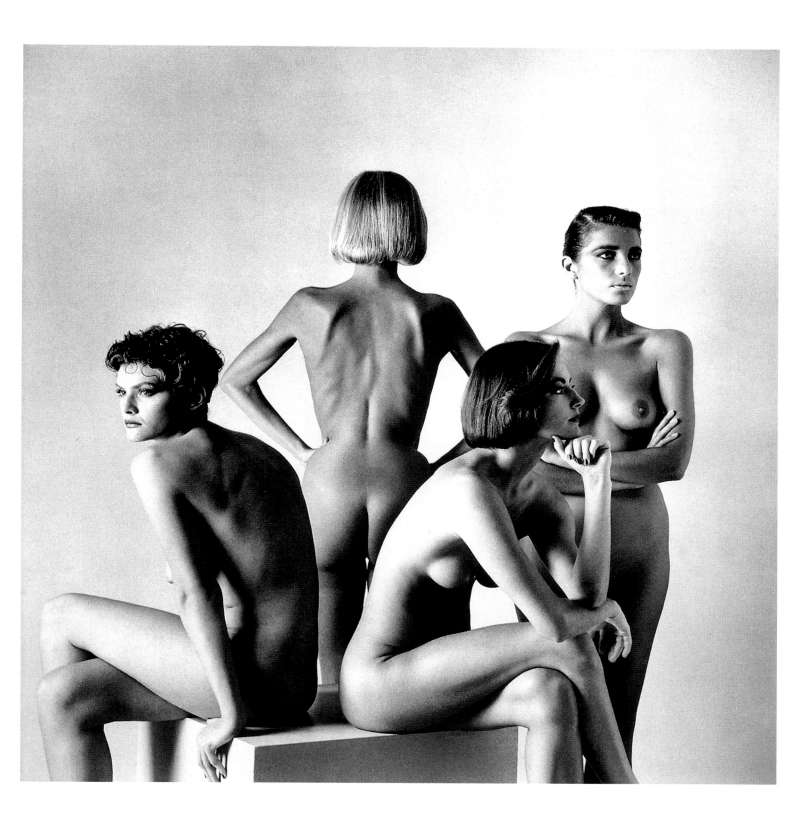

Four Nude Fashion Models Sitting, Paris 1981

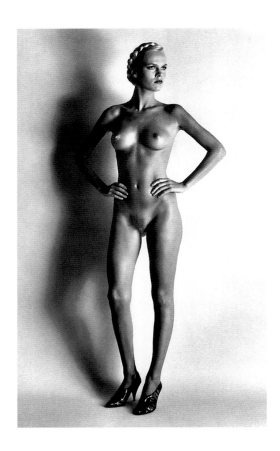
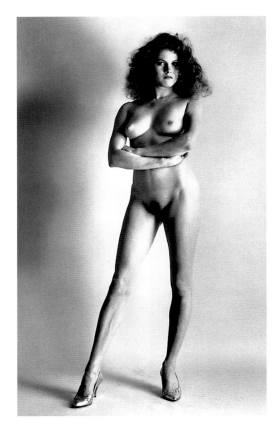

Big Nude I – V,
Paris 1980

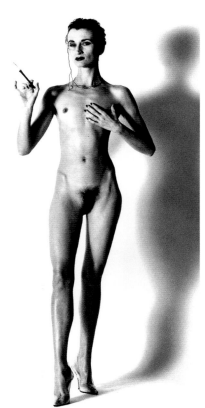
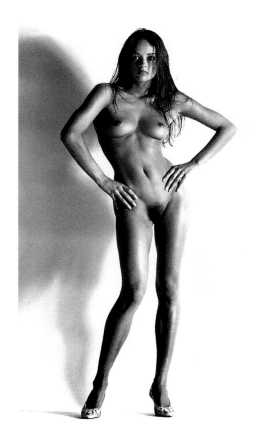

IX – Violetta with
Monocle, 1991
XI – Verina, Nice 1993
XIII – The daughter
of Genghis Khan, 1993
XV – Raquel, Nice 1993
VII – Nancy La Scala,
Nice 1990

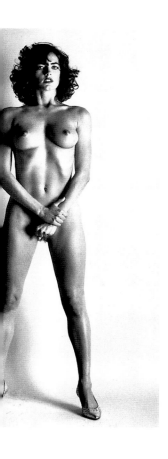
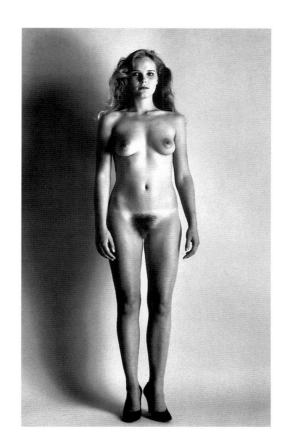
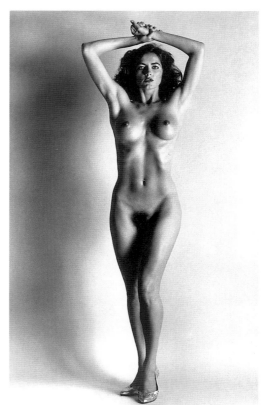
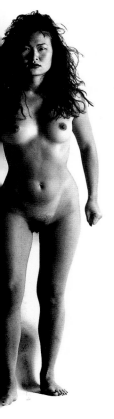
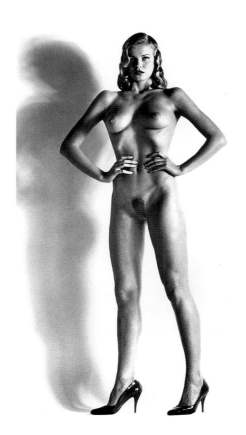
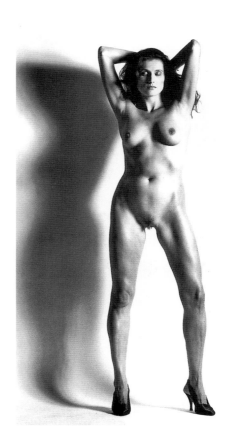

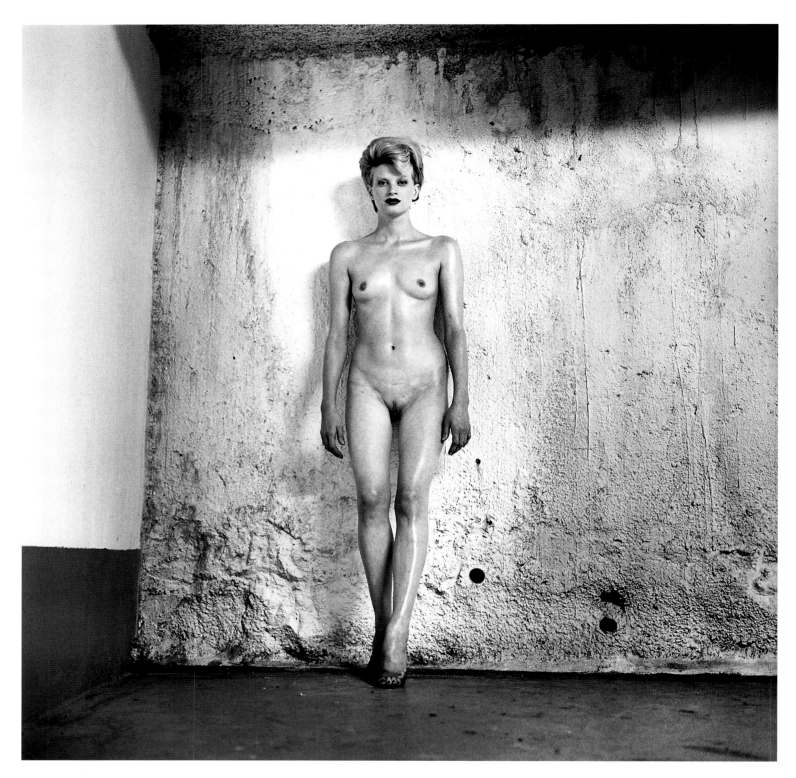

Kristen McMenamy, Monte-Carlo 1995

162

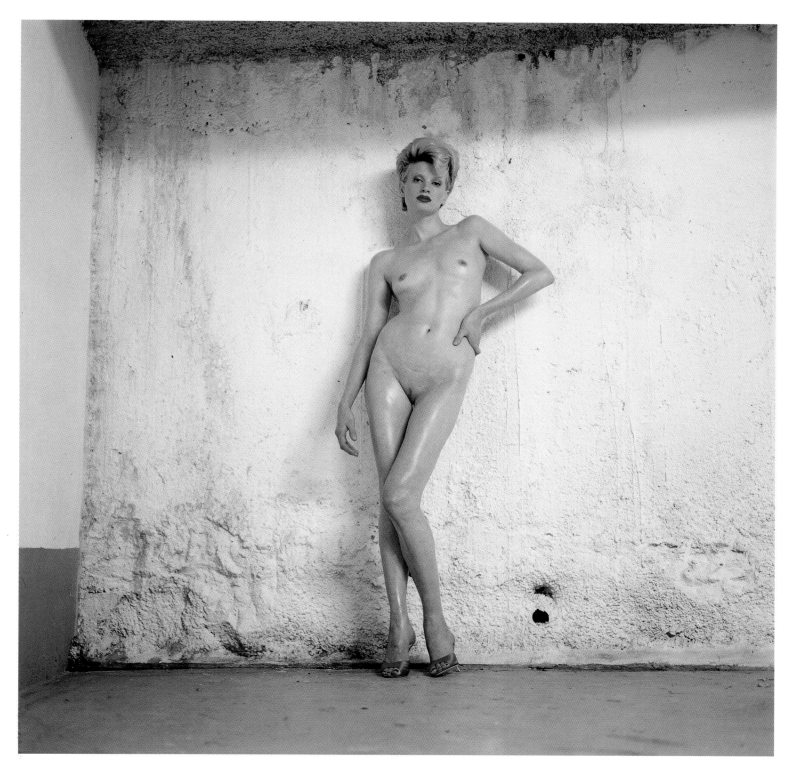

Kristen McMenamy, Monte-Carlo 1995

163

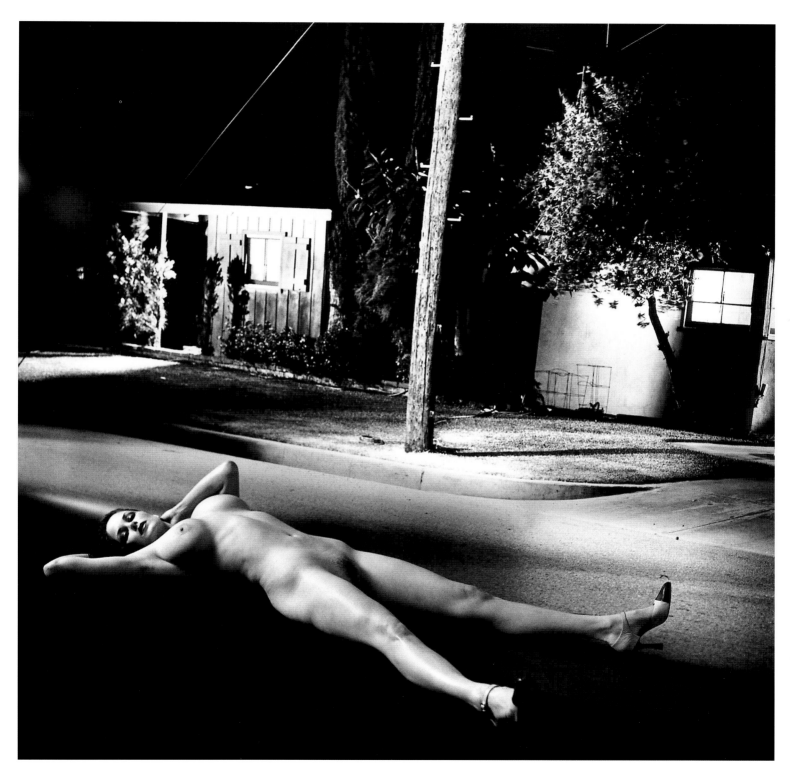

American Playmate IV, Los Angeles 1997

165

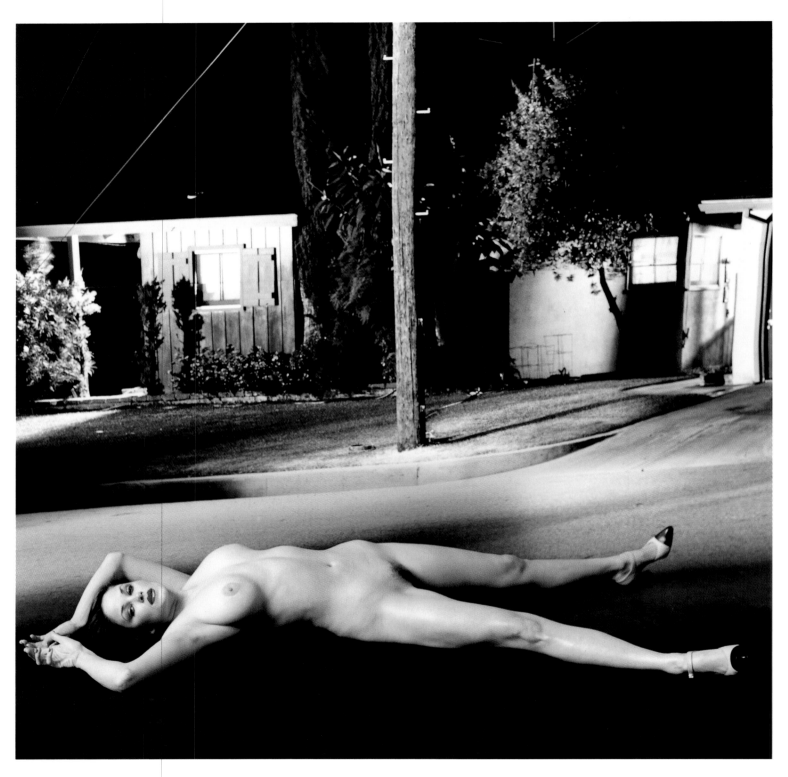

American Playmate IV, Los Angeles 1997

166

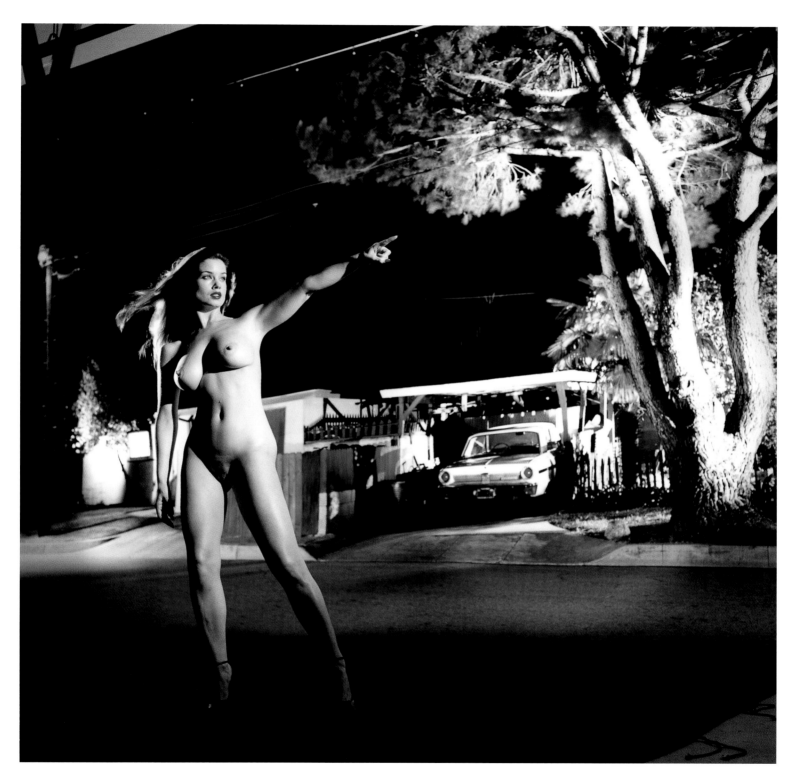

American Playmate III, Los Angeles 1997

167

American Playmate III, Los Angeles 1997

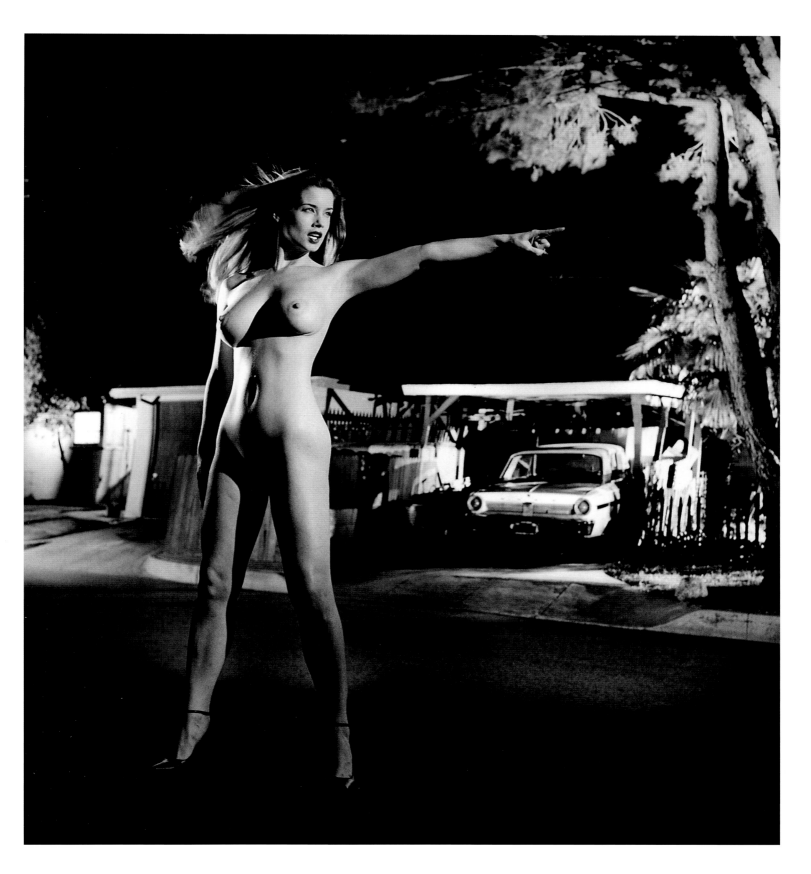

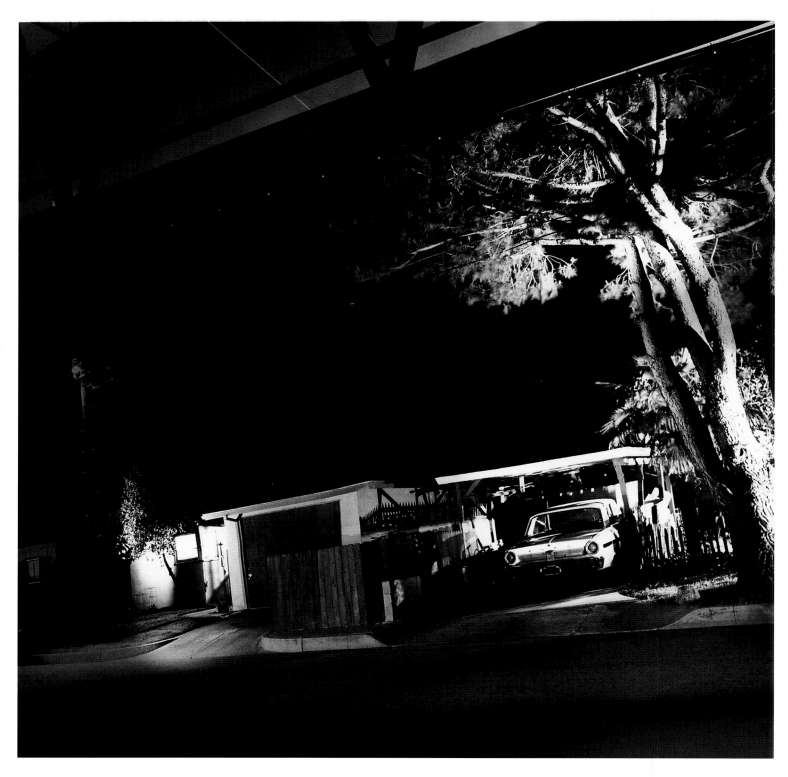

American Playmate's Landscape, Los Angeles 1997

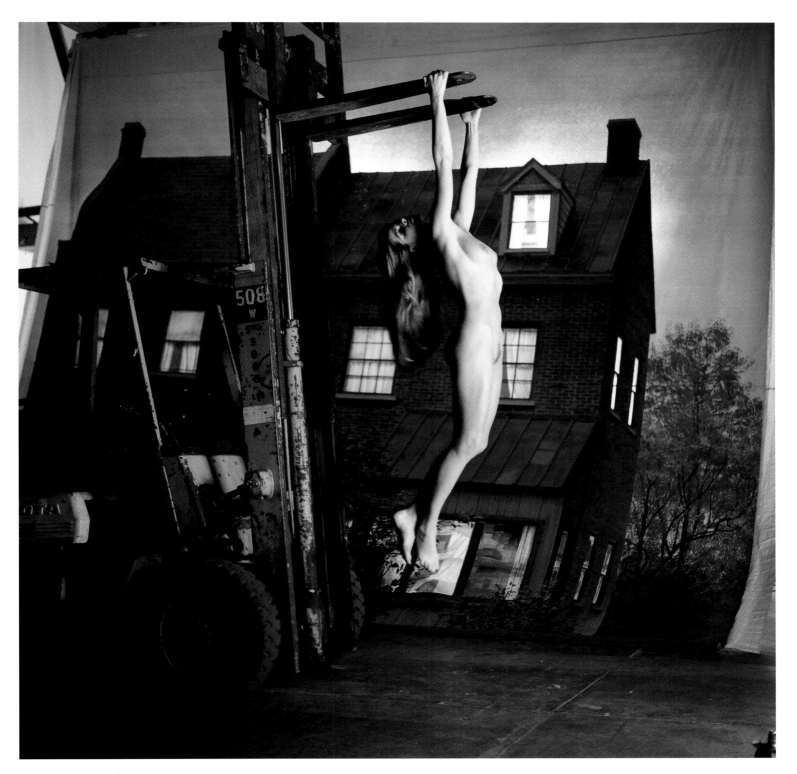

American Playmate II, Los Angeles 1997

171

American Playmate II, Los Angeles 1997

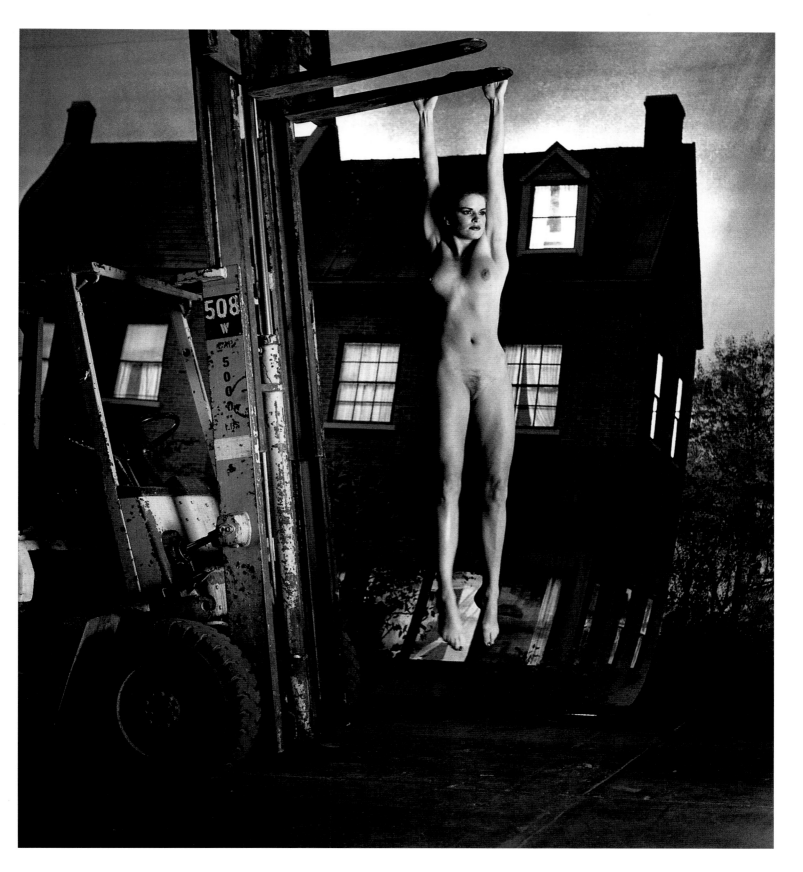

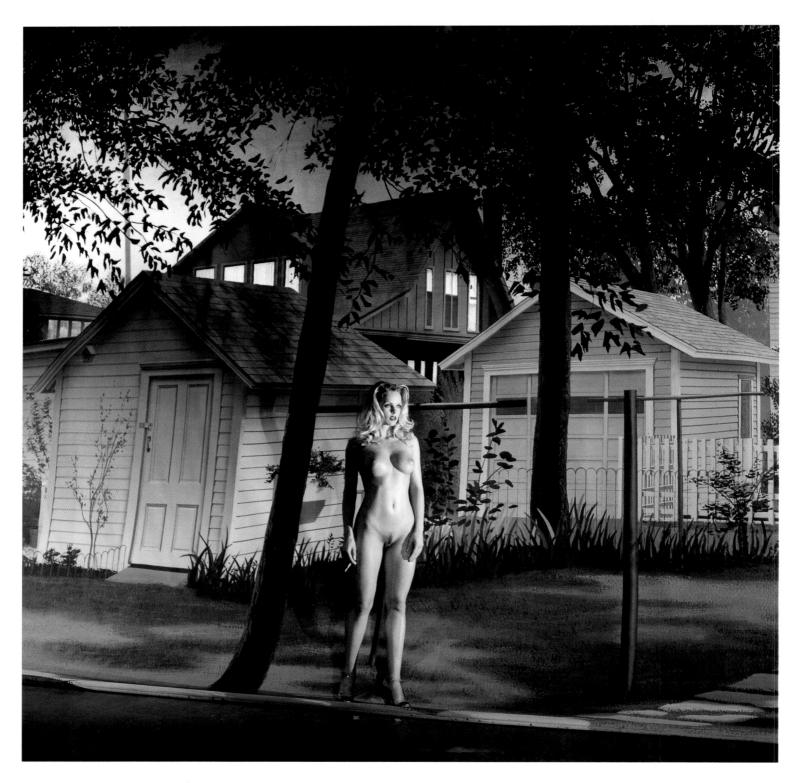

American Playmate I, Los Angeles 1997

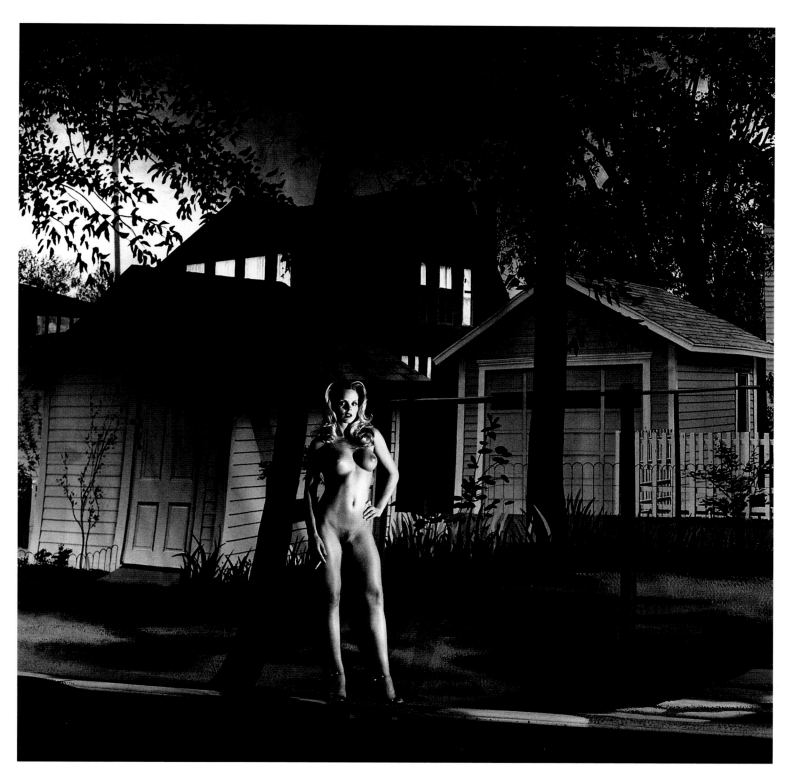

American Playmate I, Los Angeles 1997

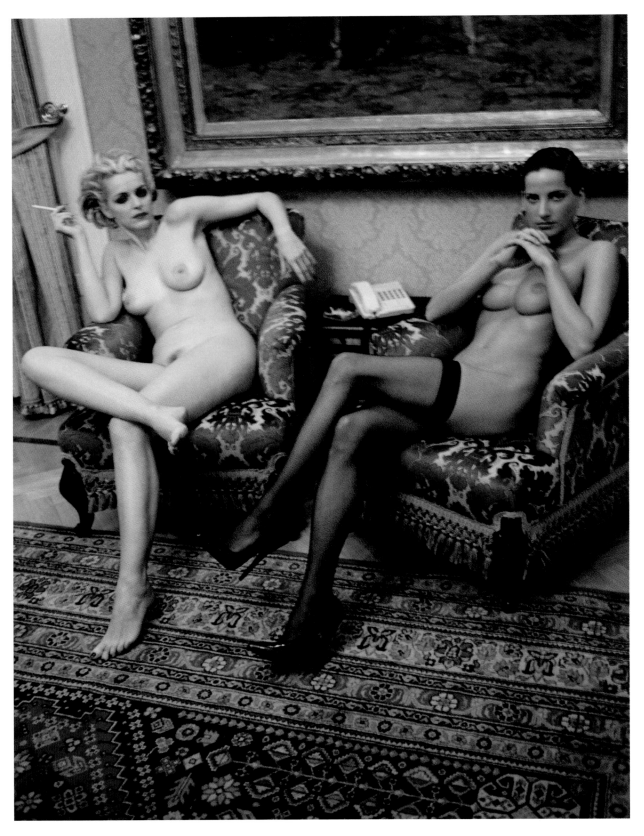

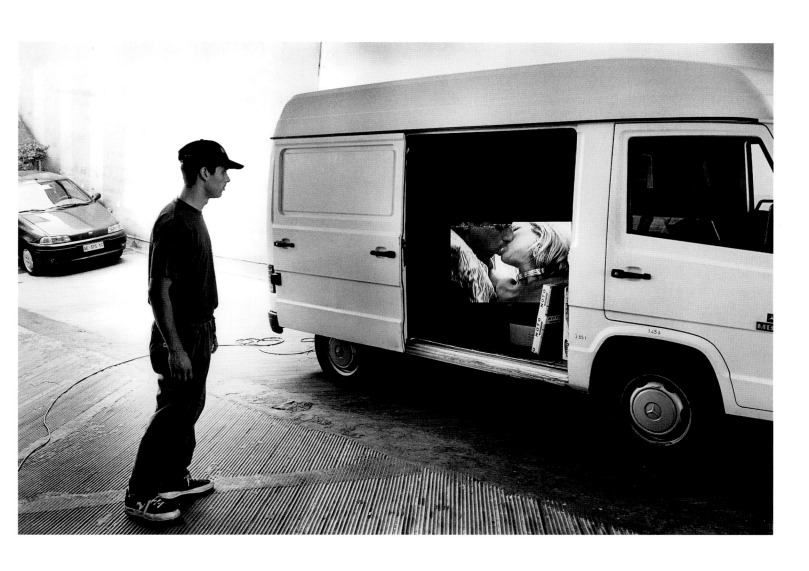

◀ Simonetta and Renée in the Verdi Suite of the Grand Hotel, Milan 1997 | TV Delivery Car, Milan 1997

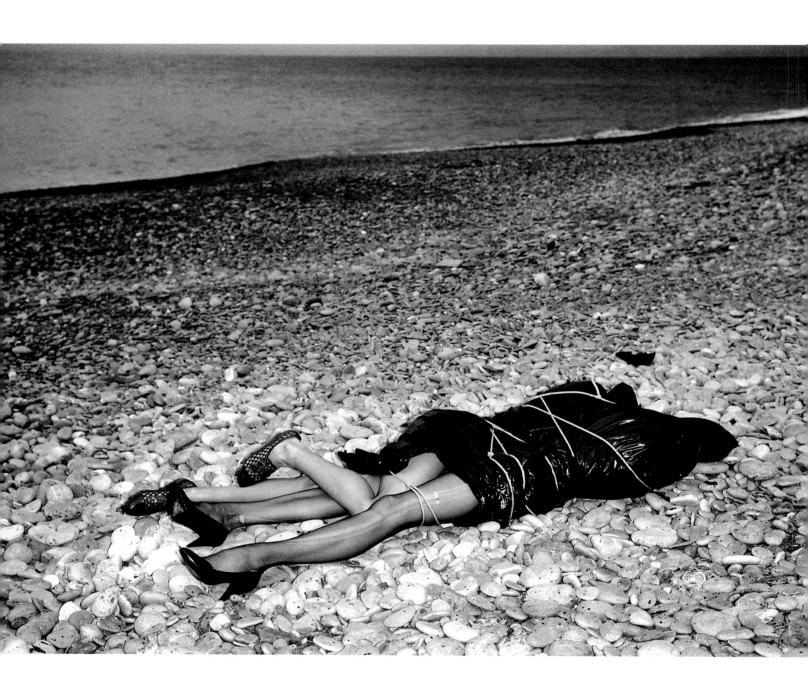

On the beach, Bordighera, Italy 1984 | June, Renault factory near Paris, 1997 ▶

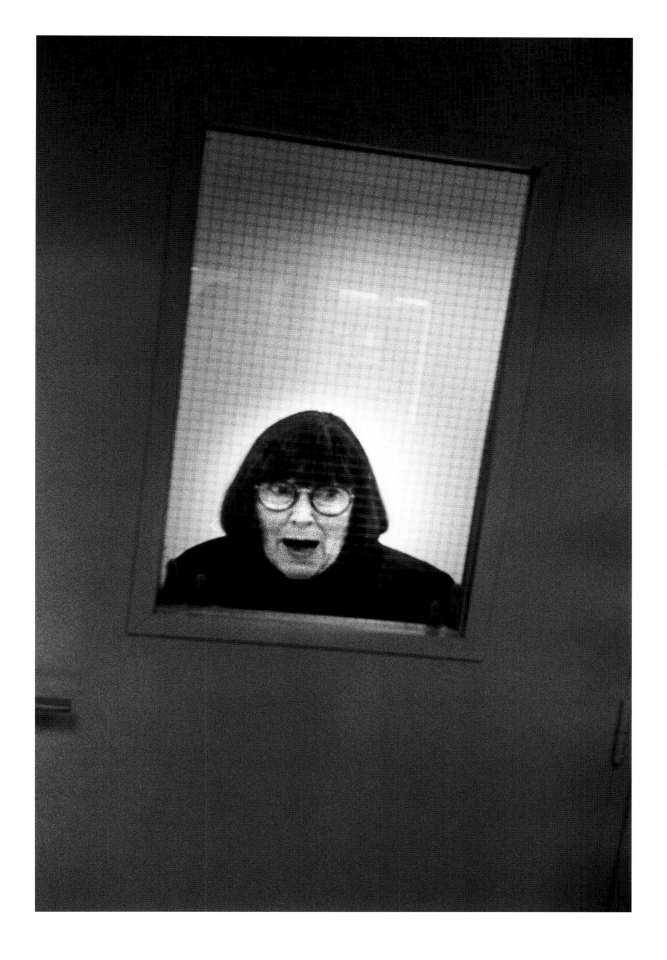

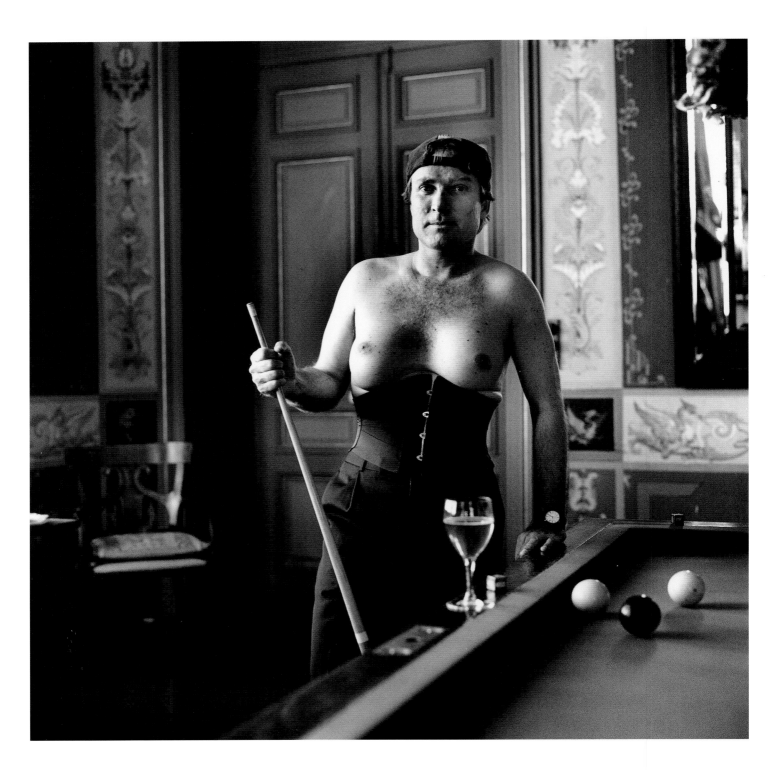

Brian the Gambler, Nice 1997

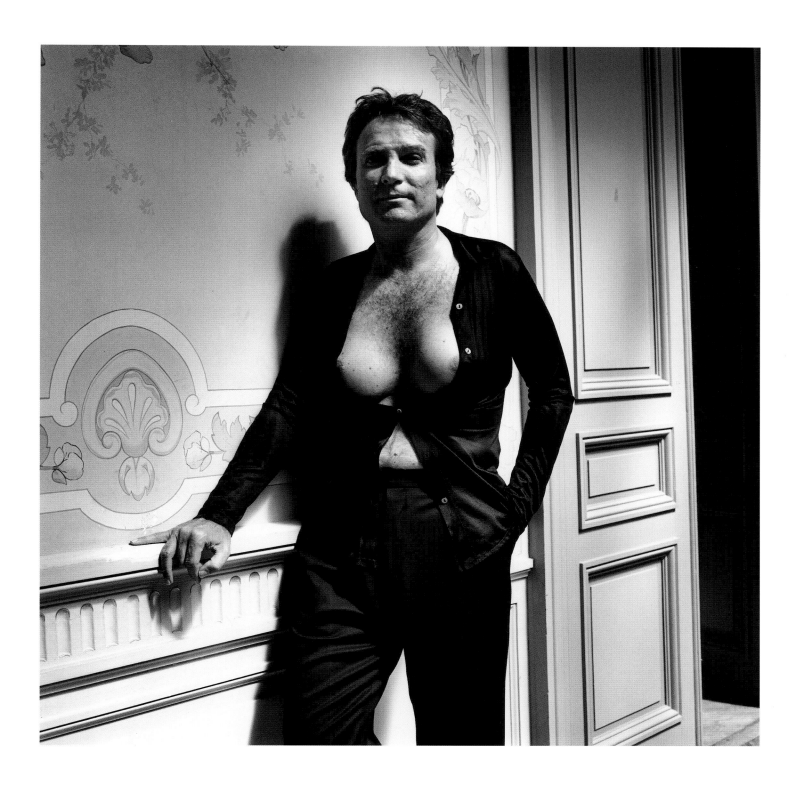

Brian the Gambler, Nice 1997

Self-portrait, Clinique St. Jean, Cagnes-sur-Mer, September 1997

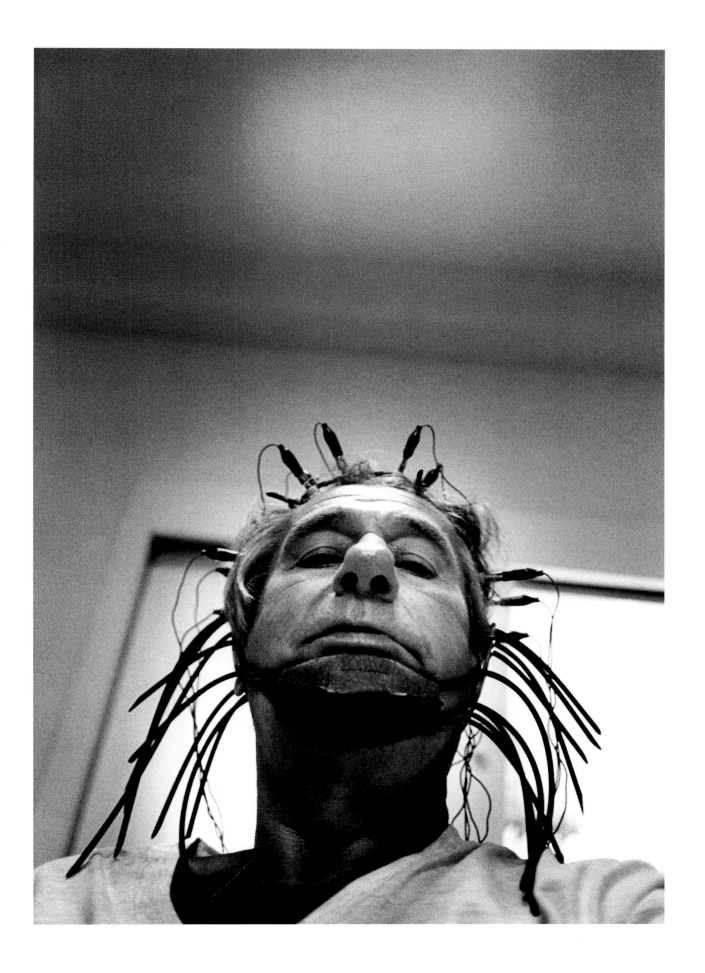

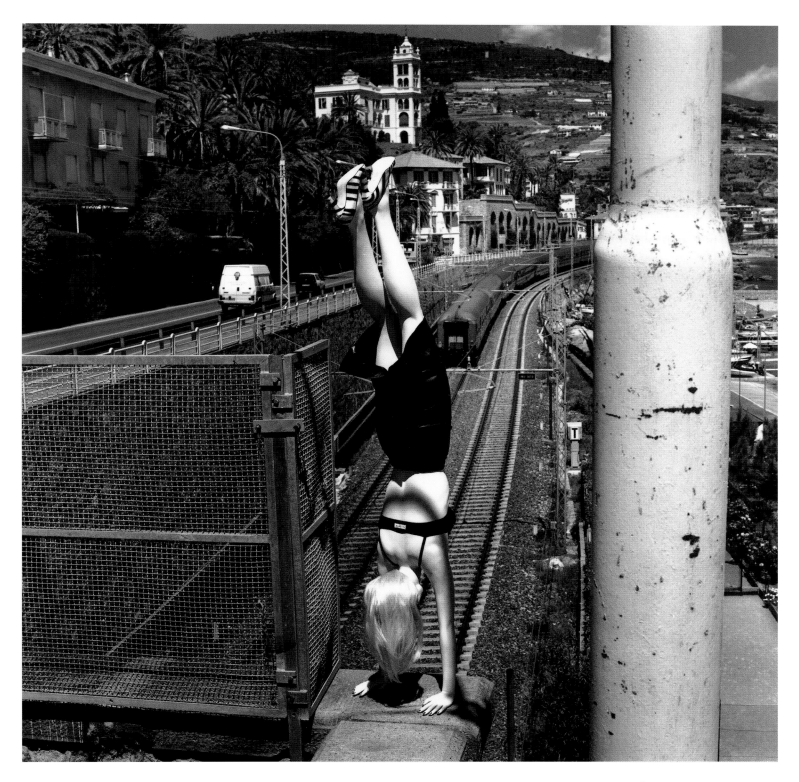

Woman doing a handstand, Bordighera, Italy 1996

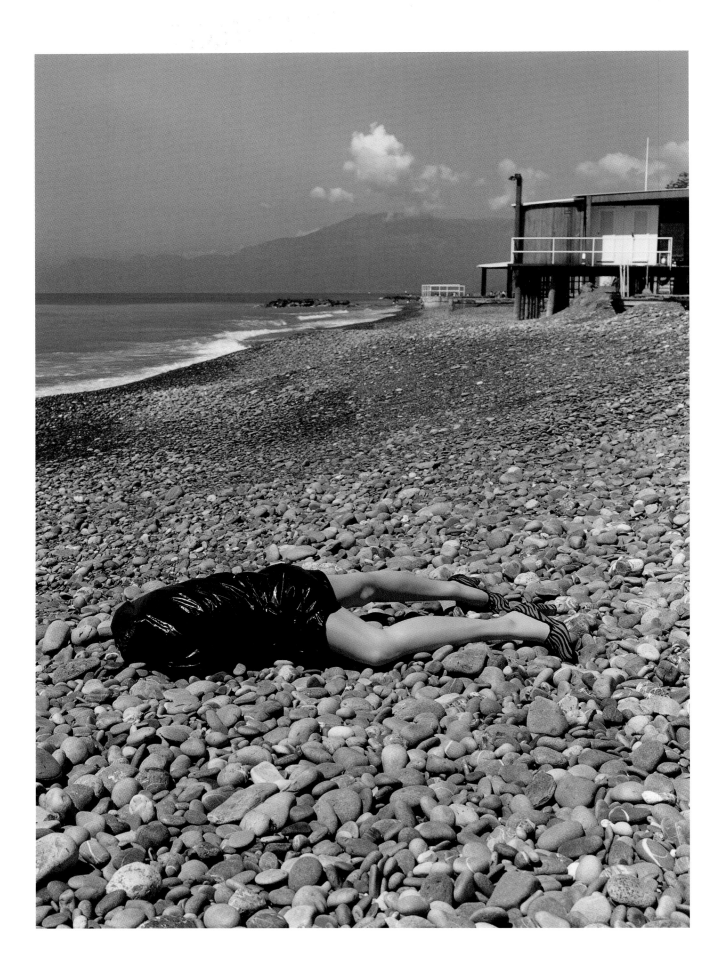

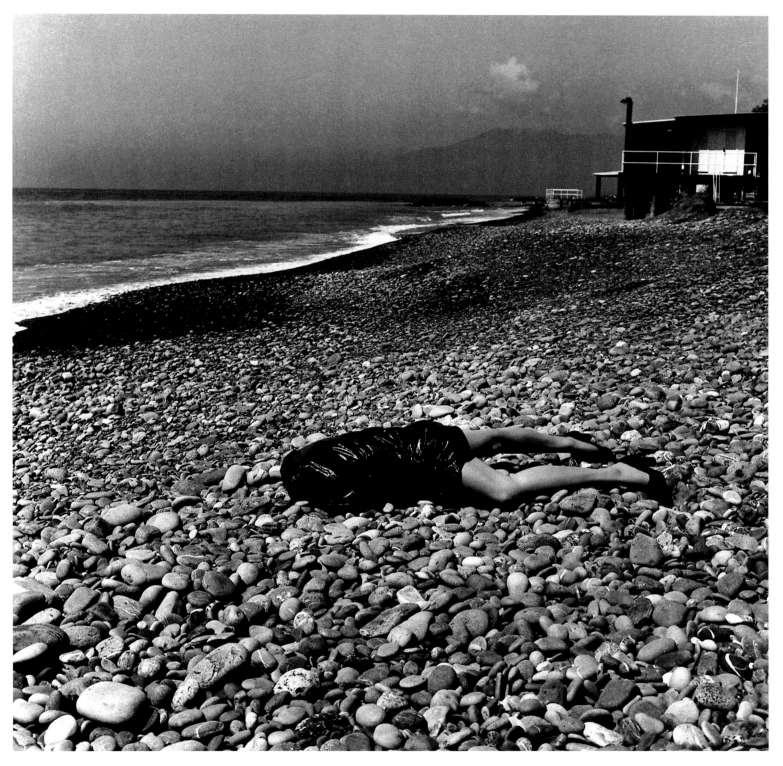

◄ On the beach, Bordighera, Italy 1996 | On the beach, Bordighera, Italy 1996

Appendix

Anton Josef Trčka

Biography

1893 Anton Josef Trčka was born in Vienna on 7 September.

1911 Art training at the *Höhere Graphische Lehr- und Versuchsanstalt* in Vienna.

1914–18 Military service.

1918 Marriage to Clara Schlesinger.

1923 Participation in the exhibition *Tvordošijni* in the Rudolfinum in Prague.

1924 Participation in the exhibition *Die Unentwegten* in the Hagebund in Vienna.

1925 Launch of the cooperative *Ringwerkstätten für Kunsthandwerk und Lichbildkunst.*

From 1929 on Trčka concentrated on writing.

1940 Trčka died in Vienna.

Selected bibliography

Die Unentwegten — Prag, Antonin Trčka, exhibition catalogue, Künstlerbund Hagen, Vienna 1924

Jakub Deml, "Nachruf," in *Slèpěje* XXVI, Tasov 1941

Josef Kroutvar, "Egon Schiele a Čechy," in *Umeni* 1988, vol. 1

Tanz:Foto, exhibition catalogue, Museum des 20. Jahrhundert, Vienna 1990

Photographie der Moderne in Prag. 1990–1925, with texts by Josef Kroutvar and Monika Faber, exhibition catalogue, Österreichisches Fotoarchiv im Museum moderner Kunst, Vienna 1991

Josef Kroutvar, "Josef Anton Trčka," in *Revue fotografie* XXX/V/4, Prague 1990

Seen & Unseen, exhibition catalogue, Galerie Rudolf Kicken, Cologne 1991

Josef Anton Trčka, exhibition catalogue, Kunstgewerbemuseum Prag and Egon-Schiele-Zentrum Krumau, 1995/96

Edward Weston

Biography

1886 Edward Weston was born in Highland Park, Illinois, on March 24.

1892–1902 Attends grammar school in Chicago.

1902 First photographs with a Kodak Bull's Eye #2.

1903 Begins working as an errand boy and clerk in a department store in Chicago.

1906 First amateur-photograph published. In May Weston moves to Tropico (today Glendale), California. Works as independent photographer.

1907 Attends the Illinois College for Photography in Chicago for two years.

1909 Returns to California. Marries Flora Chandler (Weston had four sons with her: Chandler, 1910; Brett, 1911; Neil, 1916; Cole, 1919).

1911 Opens portrait studio.

1915 Visits the Panama *Pacific International Exhibition* in San Francisco. He is deeply impressed by many works of European avant-garde art.

1917–21 Receives many awards of national and international photo-exhibitions.

1922 Break-through as an artist with the photographs of Armco Steel Mill in Ohio. In November he meets Stieglitz, Sheeler and Strand in New York.

1923 Sails for Mexico with Tina Modotti and son Chandler. Exhibition at the Aztec Land Gallery.

1924 Returns to Glendale with Chandler for six months.

1925 Returns to Mexico. Exhibits with Tina Modotti in Guadalajara.

1926 Travels through southern Mexico making photographs for Anita Brenner's *Idols Behind Altars*.

1927 Moves to his sons in Glendale. Befriends painter Henrietta Shore, who inspires his stylistic abstractions of shells, nudes and peppers.

1928 Portrait studio with Brett in San Francisco.

1929 Moves with Brett to Carmel.

1930 First solo-exhibition in New York at Delphic Studios.

1932 Weston co-founds the short-lived group *f/64* (together with Ansel Adams, Imogen Cunningham, Willard Van Dyke, Sonya Noskowiak a. o.).

1934 Meets Charis Wilson, who becomes his wife in 1938.

1937–39 A Guggenheim Foundation fellowship allows him to travel through the American West.

1941 Travels across the United States to illustrate Walt Whitman's *Leaves of Grass*.

1945 Charis and Weston divorce. First symptoms of Parkinson's disease.

1946 Weston retrospective at the Museum of Modern Art, New York.

1947 Experiments with colour-photography.

1948 Last photographs (Point Lobos). Film of Van Dyke about Edward Weston, *The Photographer*.

1950 Large-scale retrospective in Paris.

1952–53 Realisation of the so-called "Project Prints" under Weston's supervision.

1958 Edward Weston dies at his home in Carmel, California, on January 1.

Selected solo-exhibitions

1914 Friday Morning Club, Los Angeles

1915 Shakespeare Club, Pasadena

1916 Normal School, Los Angeles | Tropico Thursday Club, Tropico | Friday Morning Club, Los Angeles

1921 Shaku-Do-Sha, Los Angeles

1922 MacDowell Club, Los Angeles

1923 Aztec Land Gallery, Mexico City

1924 Aztec Land Gallery, Mexico City

1925 Japanese Club on East 1st Street, Los Angeles

1927 San Diego Museum, San Diego | Shaku-Do-Sha, Los Angeles |
Los Angeles Camera Club Exhibit, Los Angeles

1929 Highlands Inn, Carmel | Carmel Playhouse, Carmel

1930 Braxton Gallery, Hollywood | Fine Arts Museum, Houston | Delphic Studios, New York |
Vickery, Atkins and Torrey Gallery, San Francisco | Fort Dearborn Camera Club, Chicago |
Jake Zeitlin Gallery, Los Angeles

1931 Botanic Gardens, Brooklyn | Fine Arts Gallery, Balboa Park, San Diego |
Denny Watrous Gallery, Carmel | Japanese Quarter, Los Angeles |
De Young Museum, San Francisco

1932 San José State College Art Department, San José, California |
Delphic Studios, New York

1933 683 Brockhurst Gallery, Oakland | Increase Robinson Gallery, Chicago |
Ansel Adams Gallery, San Francisco | Biltmore Book Shop, Los Angeles

1934 Gelber Lilienthal Gallery, San Francisco

1936 Fort Dearborn Camera Club, Chicago

1937 Nierendorf Gallery, New York: *An American Photographer: Edward Weston* |
San Francisco Museum of Art, San Francisco: *Retrospective*

1939 Photographic Art Society of San Diego, Balboa Park, San Diego |
Harry Champlin Gallery, Beverly Hills | Jake Zeitlin Book Shop, Los Angeles

1940 Sternberg-Davis Gallery, Tucson | Crocker Art Gallery, Sacramento |
Hall of State Museum, Dallas

1942 Office of War Information, Washington, D. C.

1944 Form and Formula, Cincinnati

1946 Henry E. Huntington Library, San Marino, California |
Worcester Art Museum, Massachusetts

1947 Smithsonian Institution, Washington, D. C.

1950 New York Camera Club, New York

1952 Art Institute, Chicago

1956 Smithsonian Institution, Washington, D. C.: *The World of Edward Weston*
(itinerant exhibition) | Milwaukee Art Institute, Milwaukee |
Art Institute of Chicago, Chicago

1975 Museum of Modern Art, New York: *Retrospective*

1983 San Francisco Museum of Modern Art, San Francisco: *Edward Weston in Mexico: 1923 – 1926*
(itinerant exhibition)

1986 Center for Creative Photography: *Supreme Instants* (itinerant exhibition)

1996 Kunsthalle Düsseldorf, Fotomuseum Winterthur: *Edward Weston,
Fotografien der Lane Collection*

Selected bibliography

This bibliography lists only a small selection of the numerous publications on the work of Edward Weston. A comprehensive bibliography is to be found in: Amy Conger, *Edward Weston: Photographs from the Collection of the Center for Creative Photography*, Tucson 1992.
We renounced to list the numerous texts by Edward Weston and instead refer to the comprehensive anthology put together by Peter C. Bunnell: *Edward Weston on Photography*, Salt Lake City 1983.

Peter C. Bunnell, *Edward Weston on Photography*, Salt Lake City 1983

Peter C. Bunnell, David Featherstone (eds.), *EW 100: Centennial Essays in Honor of Edward Weston. Untitled 41*, with texts by Robert Adams, Andy Grundberg, Estelle Jussim, Alan Trachtenberg, Edward Weston, Charis Wilson a. o., Friends of Photography, Carmel, California, 1986

Leslie Squyres Calmes, *The Letters Between Edward Weston and Willard Van Dyke*, Center for Creative Photography, Tucson 1992

Amy Conger, *Edward Weston in Mexico*, University of New Mexico Press, Albuquerque 1983

Amy Conger, *Edward Weston: Photographs from the Collection of the Center for Creative Photography*, Center for Creative Photography, Tucson 1992

R. H. Cravens, *Edward Weston*, Aperture, New York 1988

Susan Danly, Weston Neaf, *Edward Weston in Los Angeles*, The Huntington Library, San Marino and the J. Paul Getty Museum, Malibu 1986

Keith F. Davis, *Edward Weston: One Hundred Photographs from the Nelson-Atkins Museum of Art and the Hallmark Photographic Collection*, Rockhill Nelson Trust, Kansas City 1982

Jürgen Harten, Urs Stahel, *Edward Weston, Fotografien der Lane Collection, Museum of Fine Arts, Boston*, Kunsthalle Düsseldorf and Fotomuseum Winterthur, 1996

Ben Maddow, *Edward Weston — His Life*, Aperture, New York 1973

Ben Maddow, *Edward Weston — His Life and Photographs*, Aperture, New York 1979

Gilles Mora (ed.), *Edward Weston — Forms of Passion*, with texts by Gilles Mora, Terence Pitts, Trudy Wilner Stack, Theodore E. Stabbins jun. and Alan Trachtenberg, Editions du Soleil, Paris 1995

Beaumont Newhall, *Supreme Instant — The Photography of Edward Weston*, Little Brown and Company, Boston, and Center for Creative Photography, Tucson 1986

Beaumont Newhall, Amy Conger (eds.), *Edward Weston Omnibus — A Critical Anthology*, with texts by Ansel Adams, Clement Greenberg, Diego Rivera, David Alfaro Siqueiros, John Szarkowski, Dody Weston Thompson a. o., Peregrine Smith, Utah 1984

Nancy Newhall (ed.), *The Photographs of Edward Weston*, Museum of Modern Art, New York 1946

Nancy Newhall, *The Daybooks of Edward Weston*, 2 vols., Rochester, New York 1961

Nancy Newhall, *Edward Weston — The Flame of Recognition*, Aperture, New York 1971

Terence Pitts, *Edward Weston — Color Photography*, Center for Creative Photography, Tucson 1986

Karen E. Quinn, Theodore E. Stebbins jun., *Weston's Westons — California and the West*, Bulfinch Press/Little Brown and Company, Boston 1994

Theodore E. Stebbins jun., *Weston's Westons — Portraits and Nudes*, Museum of Fine Arts, Boston 1990

Edward Weston, Charis Wilson, *California and the West. A Statement by Edward Weston*, Duell, Sloane and Pearce, New York 1940; Reprinted with some modifications, Aperture, New York 1978

Charis Wilson, *Edward Weston — Nudes*, Aperture, New York 1977

Helmut Newton

Biography

1920 Helmut Newton was born in Berlin on October 31.

1930–32 Attends the Heinrich-von-Treitschke-Realgymnasium in Berlin.

1933–36 Attends the American School in Berlin.

1936–38 Serves his apprenticeship to the photographer Yva in Berlin.

1938–40 Stays in Singapore.

1939 Works as press-photographer for the *Singapore Times* and is fired after two weeks due to professional incompetence.

1940 Emigrates to Australia where he lives for the next seventeen years.

1940–44 Military service in the Australian Army. Opens photo studio in Melbourne. Australian citizenship.

1947 Meets the actress June Browne (June Brunell); marriage 1948.

1956 Returns to Europe. Helmut Newton works one year in London for the British *Vogue*.

1957 Lives in Paris. Helmut Newton works in the following years regularly for the French, American, Italian and British *Vogue* and for the German magazine *Stern*.

1975 First solo-exhibition in the Nikon Gallery, Paris.

1976 Award of the Art Director's Club, Tokyo, for the best photograph.

1977/78 Award of the American Institute of Graphic Arts for his book *White Women*.

1978/79 Gold medal of the Art Director's Club, Germany, for the best photograph.

1981 Helmut Newton moves to Monte Carlo.

1989 Appointed Chevalier des Arts et des Lettres. Receives the Photographer Award for Outstanding Achievements and Contributions to Photography During the 60's and 70's from the Photographic Society of Japan. Is honoured with the Grand Prix de la Ville de Paris.

1990 Award of the Grand Prix national de la photographie.

1991 World Image Award for the best portrait-photograph, New York.

1992 Is honoured with the Grosses Bundesverdienstkreuz der Bundesrepublik Deutschland. Appointed Chevalier des Arts, Lettres et Sciences by Princess Caroline of Monaco.

1996 Appointed Commandeur de l'Ordre des Arts et des Lettres by the French minister of culture, Philippe Douste-Blazy.

Lives in Monte Carlo.

Solo-exhibitions

1975 Galerie Nikon, Paris

1976 Photographer's Gallery, London | Nicholas Wilder Gallery, Los Angeles

1978 Marlborough Gallery, New York

1979 American Center, Paris

1980 G. Ray Hawkins Gallery, Los Angeles

1981 Galerie Daniel Templon, Paris

1982 Studio Marconi, Milan | Galerie Denise René — Hans Mayer, Düsseldorf | Marlborough Gallery, New York | Galerie Tanit, Munich | Galerie Photokina, Cologne

1983 Gallery Asher-Faure, Los Angeles | G. Ray Hawkins Gallery, Los Angeles: *Big Nudes*

1984 Musée Chéret, Nice | Museo Palazzo Fortuny, Venice | G. Ray Hawkins Gallery, Los Angeles: *Private Property*

1984/85 Musée d'Art Moderne de la Ville de Paris, Paris: *Rétrospective*

1985 Galerie Artis, Monte Carlo

1986 Palais d'Europe, Menton at the Côte d'Azur: *Rétrospective*

1987 Rheinisches Landesmuseum Bonn; Groninger Museum, Groningen: *Retrospective* |
 Galerie Daniel Templon, Paris: *Nus inédits*

1988 Museum des 20. Jahrhunderts, Vienna; Forum Böttcherstrasse Bremen: *Retrospective* |
 Galerie Reckermann, Cologne: *New Nudes*

1988/89 Espace Photographique de Paris Audiovisuel, Paris: *Nouvelles Images* |
 National Portrait Gallery, London: *Portraits Retrospective*

1989 Metropolitan Teien Art Museum, Tokyo; Seibu Art Museum, Funabashi; Perfectural Museum
 of Art, Fukuoka; The Museum of Modern Art, Shiga (1990): *Fashion Photographs and Portraits* |
 Pushkin Museum of Fine Arts and Perwaja Galeria, Moscow: *Helmut Newton in Moscow* |
 Fundación Caja de Pensiones, Madrid: *Nuevas Imágenes*; Galleria d'Arte Moderna
 "Giorgio Morandi," Bologna; Carlsberg Glyptotek, Copenhagen (until 1990): *New Images*

1990 Kunstforum, Vienna | Hochschule für Graphik und Buchkunst, Leipzig

1991 Biennale Lyon | Museum of Modern Art, Bratislava |
 Hamilton Gallery, London: *Naked & Dressed*

1992 Pascal de Sarthes Gallery, Los Angeles: *Naked & Dressed in Hollywood* |
 Goro International Exhibition, Tokyo: *Helmut Newton* |
 Crédit Foncier de France, Paris: *Archives de nuit*

1993 Galleria Carla Sozzani, Milan: *Helmut Newton* | Centre culturel français de Rome, Rome |
 Villa Medici, Rome: *Archives de nuit*

1993/94 Deichtorhallen Hamburg; Josef Albers Museum, Bottrop; Fotomuseum Winterthur;
 Castello di Rivoli, Turin: *Helmut Newton. Aus dem photographischen Werk*

1994 Galerie Robert Vallois, Paris: *Mes derniers nus*

1995 Galerie Pierre Nouvion, Monte Carlo: *Archives de nuit* | Odakyu Museum, Tokyo:
 Helmut Newton — Photography | Hamilton Gallery, London: *Nude Works 1992 – 1995*

1996 Navio Museum, Osaka: *Helmut Newton — Photography* | Galleria Carla Sozzani, Milan:
 Pulp Fiction | Artforum Vilka Gallery, Thessaloniki: *Helmut Newton* |
 A Gallery for Fine Photography, New Orleans: *Fashion and Fantasy*

1997 Camera Works, Berlin: *Helmut Newton—Photographien* | Hasselblad Foundation
 at the Gothenburg Museum, Gothenburg: *Helmut Newton in Sweden*

Selected bibliography

White Women, preface by Philippe Garner, New York, London, Munich, Paris 1976,
 Tokyo 1983

Sleepless Nights, preface by Edward Behr, New York, London, Munich, Paris 1978

24 Photo Lithos — Special Collection, preface by Brion Gysin, New York, London, Munich,
 Paris 1979

Double Elephant Portfolio, portfolio with 15 photographs in a limited edition of 50 copies,
 New York 1981

Big Nudes, preface by Bernard Lamarche-Vadel, London, Paris 1981;
 British edition: *Helmut Newton — 47 Nudes*, German edition: *Helmut Newton*,
 preface by Karl Lagerfeld, New York, Paris, Munich, London 1982

World without Men, text by Helmut Newton, New York, Paris, Munich, London 1984

Helmut Newton — Portraits, exhibition catalogue, Musée d'Art Moderne de la Ville de Paris,
 preface by Françoise Marquet, Paris 1984

Helmut Newton, Photo Poche, published by the Centre national de la photographie, Paris 1986

Helmut Newton's Illustrated no. 1 — Sex + Power, Munich 1987

Helmut Newton's Illustrated no. 2 — Pictures from an Exhibition, preface by Helmut Newton,
 Munich 1987

Helmut Newton — Portraits. Bilder aus Europa und Amerika, text by Klaus Honnef, Munich 1987,
 2nd edition

Private Property, portfolio with 45 photographs in a limited edition of 75 copies, New York 1984
 (German book-edition with a text by Marshall Blonsky, Munich 1989)

Helmut Newton in Moscow — the photographic work, exhibition catalogue, Pushkin Museum,
 The First Gallery, and at the Decorative Art Gallery, Moscow 1989

Helmut Newton — Nuevas Imágenes, text by Klaus Honnef, exhibition catalogue,
 Fundación Caja de Pensiones, Madrid 1989

Helmut Newton — New Images, texts by Ennery Taramelli and Laura Leonelli, exhibition catalogue,
 Galleria d'Arte Moderna "Giorgio Morandi," Bologna 1989

Helmut Newton's Illustrated no. 3 — I was there, Munich 1991

Pola Woman, preface by Helmut Newton, Munich 1992

Archives de nuit, preface by José Alvarez, exhibition catalogue, Credit Foncier de France,
 Paris, Munich 1992

Helmut Newton. Aus dem photographischen Werk, texts by Urs Stahel and Noemi Smolik,
 exhibition catalogue, Deichtorhallen Hamburg; Josef Albers Museum, Bottrop;
 Fotomuseum Winterthur; Castello di Rivoli, Turin, 1993–94

Mes derniers nus, texts by Helmut Newton and José Alvarez, exhibition catalogue,
 Galerie Robert Vallois, Paris 1994

Helmut Newton's Illustrated no. 4 — Dr. Phantasme, Munich 1995

Helmut Newton — Photography, exhibition catalogue, Odakyu Museum, Tokyo; Navio Museum,
 Osaka, 1995

List of works

The list of works specifies firstly the works of each photographer reproduced in the catalogue in the order they occur. Additional works shown in the exhibition are listed at the end of each section in chronological order. Measurements are given in height and then width.

Anton Josef Trčka

Courtesy for all works of Anton Josef Trčka: Galerie Rudolf Kicken, Cologne. The loans come from private collections in Prague and Vienna.

page 21
Self-portrait, circa 1914
Brome silver print, vintage print
14 x 11.5 cm

page 22
Portrait of the dancer Bertl Komauer, circa 1930
Brome silver print, vintage print
14.2 x 19 cm

page 29
Self-portrait with camera, 1912
Brome silver print, vintage print
13.8 x 8.5 cm

page 30
Portrait of the photographer's sister,
Božena, 1912
Brome silver print, vintage print
17.3 x 6.9 cm

page 31
Portrait of the photographer's sister,
Božena, circa 1913
Brome silver print, vintage print
16.7 x 6.8 cm

page 32
Self-portrait with painting, 1913
Brome silver print, vintage print, painted
circa 16.3 x 12.8 cm

page 33
Self-portrait with bird, 1926
Brome silver print, vintage print
16.9 x 21.9 cm

page 35
Portrait of the painter Robert Fuchs, 1914
Brome silver print, vintage print
24.3 x 17.8 cm

page 36
Portrait of the poet Peter Altenberg, 1914
Brome silver print, vintage print
14.5 x 12.8 cm

page 37
Portrait of the poet Josef Machar, 1914
Brome silver print, vintage print
22.3 x 18.3 cm; Mount: 29.7 x 22.8 cm

page 38
Portrait of the painter Gustav Klimt, 1914
Brome silver print, vintage print
23.3 x 20.1 cm

page 39
Portrait of the painter Gustav Klimt, 1914
Brome silver print, vintage print
18 x 23.8 cm

page 41
Portrait of the painter Egon Schiele, 1914
Brome silver print, vintage print
15.3 x 6.2 cm; Mount: 29.2 x 22.3 cm

page 42
Portrait of the painter Egon Schiele, 1914
Brome silver print, vintage print
20.6 x 16.1 cm

page 43
Portrait of the painter Egon Schiele
with painting, 1914
Brome silver print, vintage print
22.1 x 17.4 cm

page 67
Semi-nude, circa 1927
Brome silver print, vintage print
16.1 x 10.6 cm

page 69
Portrait of the poet Robert Michel, 1926
Brome silver print, vintage print
17.5 x 13.6 cm

page 70
Portrait of the poet Felix Braun, 1926
Brome silver print, vintage print
16.4 x 11.8 cm

page 71
Portrait of the poet Felix Braun, 1927
Brome silver print, vintage print
21 x 15.8 cm

page 72
Hilde Holger (?) wearing a white collar,
circa 1928
Brome silver print, vintage print
16.5 x 20.9 cm

page 73
Hilde Holger wearing a metal costume,
circa 1928
Brome silver print, vintage print
18 x 12.9 cm

not depicted:

Woman with dove, circa 1926
Brome silver print, vintage print
15.8 x 20.4 cm

Portrait of the painter Max Wolff, 1928
Brome silver print, vintage print
23.5 x 16.7 cm

Edward Weston

page 83
Tina Modotti: Edward Weston with Seneca
View Camera, circa 1924
Gelatin silver print, vintage print
18.4 x 22.4 cm; unsigned
Collection of Matthew Weston, Weston Gallery,
Carmel, California

page 85
Hands against Kimono (Tina Modotti), 1923
Platinum palladium print, vintage print
22.9 x 19.4 cm
mount recto: initialled and dated; mount verso:
titled, signed and dated; print verso: signed,
dated and annotated
Collection of Margaret Weston, Weston Gallery,
Carmel, California

page 86
Bride, circa 1920
Platinum print, vintage print
23.7 x 18.3 cm
The Manfred Heiting Collection, Amsterdam

page 87
Lois Kellogg, 1923
Platinum print, vintage print
23,5 x 19 cm; mount: 45,3 x 35,5 cm
mount verso: signed and dated with pencil
The Manfred Heiting Collection, Amsterdam

page 89
Tina Reciting, 1924 (Tina Modotti)
Warm-toned palladium print, vintage print
23.7 x 19.2 cm; mount: 45.6 x 35.5 cm
mount recto: signed with pencil;
mount verso: lower left signed and marked
"Edward Weston—Mexico 1924," lower right:
noted with pencil: "Tina"
The Manfred Heiting Collection, Amsterdam

page 90
The Ascent of Attic Angels, circa 1921
Platinum print, vintage print
23.5 x 19 cm
mount recto: signed, titled and dated
Collection of Margaret Weston, Weston Gallery,
Carmel, California

page 91
The White Iris, Tina Modotti, 1921
Platinum palladium print, vintage print
20.6 x 19 cm; unsigned
Collection of Margaret Weston, Weston Gallery,
Carmel California

page 93
Pipes and Stacks (Armco Steel), Armco,
Middletown, Ohio, 1922
Warm-toned palladium print, vintage print
24.3 x 19.2 cm; mounted on vellum: 45.9 x 35.7 cm
mount recto: lower right signed
"Edward Weston/Ohio 1922," lower left titled
"Pipes and Stacks," dedication: "for Charlot—/
with much appreciation Edward Weston—
Mexico 1924." Edition: one of two known
palladium prints; Weston records in his log
book that he made a maximum of eight prints
The Manfred Heiting Collection, Amsterdam

page 94
Whale Vertebrae, Point Lobos, 1934
Gelatin silver print, vintage print
19.3 x 24.4 cm
mount recto: signed, dated and numbered
with pencil; mount verso: dedicated to
"Leon Wilson," numbered with number of
negative "208" and dated.
Edition: 2/50
Collection of Matthew Weston, Weston Gallery,
Carmel, California

page 95
Pulquería Mural (Matador and Arena), 1926
Gelatin silver print, vintage print
19 x 23.8 cm; unsigned
Collection of Margaret Weston, Weston Gallery,
Carmel, California

page 97
Tres Ollas (Oaxaca Pots), 1926
Gelatin silver print, vintage print
19 x 21,3 cm; unsigned
Collection of Margaret Weston, Weston Gallery,
Carmel, California

page 99
Excusado, Mexico, 1925
Gelatin silver print, vintage print (at the end
of the 30's)
24.1 x 18.9; Mount: 50.8 x 40.6 cm
mount recto: initialled and dated with pencil;
mount verso: titled, dated and numbered
with "5M"
Collection of Margaret Weston, Weston Gallery,
Carmel California

page 100
Cypress Root and Stone Crop, Point Lobos, 1930
Gelatin silver print, vintage print
19.1 x 24.1 cm; mount: 31.7 x 39.5 cm
mount verso: signed, dated and numbered
with pencil
Edition: 4/50 (according to Weston's record
book not more than six prints were made)
The Manfred Heiting Collection, Amsterdam

page 101
Oak, Monterey County, 1929
Gelatin silver print, vintage print
19.2 x 24 cm; mount: 38 x 39.3 cm
mount recto: signed, dated and numbered
Edition: 2/50 (no more than 12 prints are
known to exist)
The Manfred Heiting Collection, Amsterdam

page 103
Chambered Nautilus
Gelatin silver print, vintage print
24.4 x 19 cm; mount: 43.5 x 35.2 cm
mount recto: signed, initialled and numbered
Edition: 20/50 (printed in the 30's)
Collection of Margaret Weston, Weston Gallery,
Carmel, California

page 104
Eroded Rock No. 51, 1930
Gelatin silver print, vintage print
17.1 x 24.4 cm; mount: 37.8 x 38.7 cm
mount recto: signed, initialled, dated
and numbered; mount verso:
negative-number: "51R"
Edition: 5/50 (printed in the 30s)
Collection of Margaret Weston, Weston Galley,
Carmel, California

page 105
Pepper No. 30, 1930
Gelatin silver print, vintage print
23.8 x 19 cm; mount: 45.7 x 35.6 cm
mount recto: signed, dated and numbered
with pencil, "30P," other marks: "probably
from an exhibition circulated in Great Britain
1938 – 40" and "$ 525/Burnside 1/73/Sotheby's
Lot," mount verso: red stamp of the
Weston Neaf Collection
Edition: 22/50 (Weston's record book
mentions not more than 25 prints)
The Manfred Heiting Collection, Amsterdam

page 106
Egg Slicer, 1930
Gelatin silver print, vintage print (probably
from the 30's)
19 x 22.8 cm
mount verso: titled and number of negative:
"24M," stamp of artist and signature
Collection of Margaret Weston, Weston Gallery,
Carmel, California

page 107
Chinese Cabbage, 1931
Gelatin silver print, vintage print
23.5 x 19.2 cm
mount verso: titled, signed, dated
Francesca Kicken, Arrow Sic

page 109
Cypress Root Seventeen Mile Drive, 1929
Gelatin silver print, vintage print
24.1 x 18.4 cm; mount: 43.1 x 35.8 cm
mount recto: signed, numbered and dated
with pencil; mount verso: marked with
negative-number "23T*"
Edition: 8/50
Collection of Margaret Weston, Weston Gallery,
Carmel, California

page 110
Charis, 1934
Gelatin silver print, vintage print
8.9 x 11.7 cm; mount: 22.9 x 27.9 cm
mount recto: signed and dated with pencil
Edition: 5/50 (in Weston's record book not
more than ten prints are mentioned)
The Manfred Heiting Collection, Amsterdam

page 111
Kelp, 1930
Gelatin silver print; vintage print (circa 1930)
19.4 x 24.1 cm; mount: 37 x 39.4 cm
mount recto: titled, dated, numbered and signed
Collection of Margaret Weston, Weston Gallery,
Carmel, California

page 112
Pelican's Wing, Point Lobos, 1931
Gelatin silver print, vintage print
20.3 x 25.4 cm; mount: 40.6 x 50.8 cm
mount recto: signed and dated
Collection of Margaret Weston, Weston Gallery,
Carmel, California

page 125
Untitled, 1941
Gelatin silver print, vintage print
19.3 x 24.3 cm
mount recto: initialled and dated "E. W., 41,"
mount verso: stamped
Francesca Kicken, Arrow Sic

page 127
Comics, Elliot Point, 1944
Gelatin silver print, vintage print
19.4 x 24.1 cm
mount recto: initialled "E. W." and dated;
mount verso: titled, signed and numbered
with negative-number "c44-Mi-1"
Collection of Margaret Weston, Weston Gallery,
Carmel, California

Helmut Newton

Courtesy for all works of Helmut Newton:
Rudolf Kicken Gallery, Cologne. All works
without indication of the lender are loans of
the Rudolf Kicken Gallery, Cologne.

page 131
Woman examining man, Saint Tropez 1975
Gelatin silver print
80 x 60 cm; exhibition print

page 139
Me and Courbet, Musée d'Orsay, Paris 1996
Gelatin silver print
50 x 60 cm; exhibition print

page 140
In a brothel in Frankfurt, 1988
Gelatin silver print
60 x 50 cm; Edition-No.: 1/10

page 145
Self-portrait, Hotel Royal Monceau, Paris 1994
Gelatin silver print
60 x 50 cm; Edition-No.: 2/10

page 146
Self-portrait, Valentino Place, Hollywood 1987
Gelatin silver print
50 x 60 cm; Edition-No.: 2/10

page 147
Self-portrait with model, Paris 1973
Colour print after Cibachrome
60 x 44 cm; exhibition print

page 148
Date Rape, Beverly Hills 1991
Gelatin silver print
80 x 60 cm; exhibition print

page 149
Polaroid paper negative, Paris 1997
Gelatin silver print
60 x 80 cm; exhibition print

page 160, bottom, very left
Big Nude IX — Violetta with Monocle, Paris 1981
Gelatin silver print
200 x 120 cm; Edition-No.: 1/3

page 160, bottom, second from the left
Big Nude XI — Verina, Nice 1993
Gelatin silver print
200 x 120 cm; Edition-No.: 3/3

page 161, bottom, third from the right
Big Nude XIII — The Daughter of Ghengis Khan,
Nice 1993
Gelatin silver print
200 x 120 cm; Edition-No.: 1/3

page 161, bottom, second from the right
Big Nude XV — Raquel, Nice 1993
Gelatin silver print
200 x 120 cm; Edition-No.: 1/3

page 161, bottom, very right
Big Nude VII — Nancy La Scala, Nice 1990
Gelatin silver print
200 x 120 cm; Edition-No.: 1/3

page 162
Kristen McMenamy, Monte Carlo 1995
Gelatin silver print
150 x 120 cm; Edition-No.: 2/6

page 163
Kristen McMenamy, Monte Carlo 1995
Colour print
150 x 120 cm; Edition-No.: 5/6

page 165
American Playmate IV, Los Angeles 1997
for American *Playboy*
Gelatin silver print
60 x 60 cm; Edition-No.: 1/6

page 166
American Playmate IV, Los Angeles 1997
for American *Playboy*
Colour print
60 x 60 cm; Edition-No.: 1/6

page 167
American Playmate III, Los Angeles 1997
for American *Playboy*
Gelatin silver print
60 x 60 cm; Edition-No.: 1/6

page 169
American Playmate III, Los Angeles 1997
for American *Playboy*
Colour print
60 x 60 cm; Edition-No.: 1/6

page 170
American Playmate's Landscape,
Los Angeles 1997
for American *Playboy*
Gelatin silver print
60 x 60 cm; Edition-No.: 1/6

page 171
American Playmate II, Los Angeles 1997
for American *Playboy*
Gelatin silver print
60 x 60 cm; Edition-No.: 1/6

page 173
American Playmate II, Los Angeles 1997
for American *Playboy*
Colour print
60 x 60 cm; Edition-No.: 1/6

page 174
American Playmate I, Los Angeles 1997
for American *Playboy*
Gelatin silver print
60 x 60 cm; Edition-No.: 1/6

page 175
American Playmate I, Los Angeles 1997
for American *Playboy*
Colour print
60 x 60 cm; Edition-No.: 1/6

page 176
Simonetta and Renée in the Verdi Suite of
the Grand Hotel, Milan 1997
Colour print
80 x 60 cm; Edition-No.: 1/6

page 177
TV Delivery Truck, Milan 1997
Gelatin silver print
60 x 80 cm; Edition-No. 1/6

page 178
On the beach, Bordighera, Italy, 1984
Gelatin silver print
77 x 104 cm; exhibition print

page 179
June, Renault factory near Paris, 1997
Gelatin silver print
80 x 60 cm; Edition-No.: 1/6

page 180
Brian the Gambler, Nice 1997
for *Details Magazine*
Gelatin silver print
60 x 60 cm; Edition-No.: 1/8

page 181
Brian the Gambler, Nice 1997
for *Details Magazine*
Gelatin silver print
60 x 60 cm; Edition-No. 1/6

page 183
Self-portrait, Clinique St. Jean, Cagnes-sur-Mer,
September 1997
Gelatin silver print
66 x 44 cm; Edition-No.: 1/10

page 185
Woman doing a handstand, Bordighera,
Italy, 1996
for Italian *Vogue*
Gelatin silver print
100 x 100 cm; Edition-No.: 1/6

page 186
On the beach, Bordighera, Italy, 1996
Colour print
80 x 80 cm; Edition-No.: 1/6

page 187
On the beach, Bordighera, Italy, 1996
Gelatin silver print
60 x 60 cm; Edition-No.: 1/6

not depicted:

105 polaroids, 1966–96
Colour and black and white
10.3 x 10.2 cm or 10.7 x 8.5 cm
Gerd Elfering, Berlin

3 polaroids, 1988–94
Colour
10.3 x 10.2 or 10.7 x 8.5 cm
Courtesy Alexander Hornemann

In Yva's Studio, Berlin 1936
Gelatin silver print
60 x 50 cm; Edition-No. 2/10

June and me — Happy at the good news
that I will live, Lenox Hill Hospital, New York 1971
Gelatin silver print
50 x 60 cm; Edition-No.: 1/10

Self-portrait, Lenox Hill Hospital, New York 1973
Gelatin silver print
50 x 60 cm; Edition-No.: 1/10

Self-portrait, Lenox Hill Hospital, New York 1973
Gelatin silver print
60 x 50 cm; Edition-No.: 2/10

Self-portrait, Hotel due Torri, Verona 1976
Gelatin silver print
50 x 60 cm; Edition-No.: 1/10

Sie kommen I, Paris 1981
Gelatin silver print
in two parts, 195 x 90 cm each
Edition-No.: 1/3
Rheinisches Landesmuseum Bonn

Sie kommen II, Paris 1981
Gelatin silver print
in two parts, 195 x 90 cm each
Edition-No.: 1/3
Rheinisches Landesmuseum Bonn

Self-portrait with wife and model,
Vogue Studio, Paris 1981
Gelatin silver print
60 x 50 cm; exhibition print

Big Nude VIII — The Two Violettas, 1991
Gelatin silver print
200 x 120 cm; Edition-No. 2/3

Big Nude X — Xenia with Monocle,
Monte Carlo 1991
Gelatin silver print
200 x 115 cm; Edition-No. 2/3

Domestic Nude II — Waiting for the earthquake,
Los Angeles 1992
Gelatin silver print
139 x 116 cm; Edition-No.: 1/3

Domestic Nude III — In the laundry room,
Chateau Marmont, Hollywood 1992
Gelatin silver print
139 x 116 cm; Edition-No. 1/3

In the police museum, Vienna, June 1992
Gelatin silver print
50 x 60 cm; Edition-No. 1/10

In my room, Hotel du Palais, Biarritz 1993
Gelatin silver print
50 x 60 cm; Edition-No. 1/10

Big Nude XVIII — Eva, Monte Carlo 1993
Gelatin silver print
200 x 120 cm; Edition-No. 1/3

Big Nude XX — Bryndis, Monte Carlo 1993
Gelatin silver print
200 x 120 cm; Edition-No. 1/3

Kristen wired, Monte Carlo 1995
Gelatin silver print
60 x 80 cm; exhibition print

Simonetta in the Verdi Suite of the Grand Hotel,
Milan 1997
Colour print
80 x 60 cm; Edition-No.: 1/6

Centre cardio-thoracique, Monte Carlo 1997
Gelatin silver print
60 x 50 cm; Edition-No. 1/6

Brian the Gambler I, Nice 1997
for *Details Magazine*
Gelatin silver print
60 x 60 cm; exhibition print

3 polaroids, 1966 – 96
Colour
10.3 x 10.2 cm or 10.7 x 8.5 cm
Camera Work, Berlin

Anton Josef Trčka Edward Weston Helmut Newton

The Artificial of the Real
March 14 – May 24, 1998
Catalogue 1/2 – 1998,
edited by Carl Haenlein,
Kestner Gesellschaft

Kestner Gesellschaft

Goseriede 11
D-30159 Hannover
Phone 49/511/701 20-0, fax 49/511/701 20-20

Members of the Board:
Dr Wolfgang Wagner, Honorary Chairman
Wilhelm Sandmann, Chairman
Dr Klaus F. Geiseler, Vice-Chairman
Christian Knoke, Treasurer
Klaus Stosberg, Secretary
Dr Manfred Bodin
Prof Dr Werner Schmalenbach

Advisory Board:
Lorenz Bahlsen
Dr Michael Borkowski
Prof Dr Carsten P Claussen
Burghard Freiherr von Cramm
Dr Alexander Erdland
Angela Kriesel
Dr Peter Raue
Dr Insa Sikken
Rolf Weinberg

Director:
Dr Carl Haenlein

Exhibition: Carsten Ahrens, Carl Haenlein, Rudolf Kicken
Exhibition office: Mairi Kroll, Natascha Ahrens
Technical staff: Jörg-Maria Brügger,
Norbert Schaft, Guido Bode, Dieter Günther

Editors for the catalogue: Carsten Ahrens, Rudolf Kicken
Collaborating editor: Oliver Seifert
Editorial assistant: Alexis Schwarzenbach, Angelika Stricker
Design: Hans Werner Holzwarth, Berlin
Reprography: Bernd Montag, Frenzel & Heinrichs, Hannover
(Trčka and 4colour plates Newton); Nova Concept, Berlin (Weston);
Druckerei Th. Schäfer, Hannover (Newton 2colour plates)
Type setting and printing: Druckerei Th. Schäfer, Hannover
Bindery: S.R. Büge, Celle

© 1998 for the photographs by Anton Josef Trčka:
Courtesy Galerie Rudolf Kicken, Köln;
for the photographs by Edward Weston:
Center for Creative Photography, Arizona Board of Regents;
for the photographs by Helmut Newton:
Courtesy Galerie Rudolf Kicken, Köln;
for the texts: the authors
© 1998 for this edition: Kestner Gesellschaft, Hannover,
and Scalo Verlag AG, Zurich

Scalo Zurich – Berlin – New York
Head office: Weinbergstrasse 22a, CH-8001 Zurich,
phone 41/1/261 0910, fax 41/1/261 9262
Distributed in North America in collaboration with
D.A.P., New York City; in Europe, Africa and Asia by
Thames and Hudson, London; in Germany, Austria
and Switzerland by Scalo.

First Scalo Edition 1998
ISBN 3-931141-88-8
Printed in Germany